CROP CIRCLES AN ART OF OUR TIME

MARY CARROLL NELSON

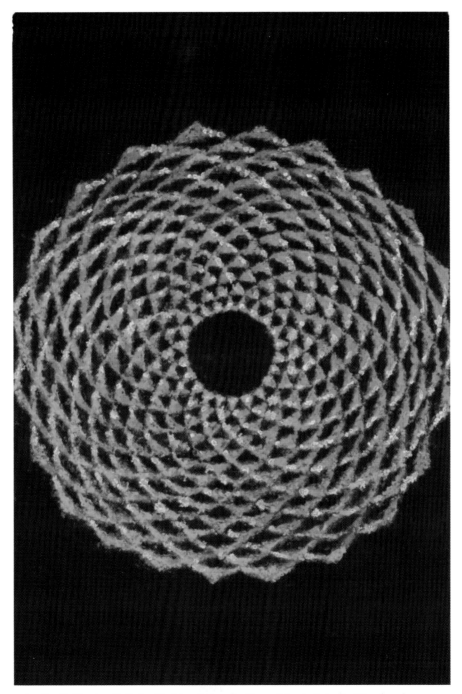

1. Lydia Ruyle *Infinity Goddess Triangles* (Logarithmic Spiral) Handmade paper
Picked Hill, Alton Barnes, Wiltshire, 2000

CROP CIRCLES AN ART OF OUR TIME

MARY CARROLL NELSON

CROP CIRCLES
SPIRITUAL INTERPRETATIONS BY ISABELLE KINGSTON

CROP CIRCLE ART BY LYDIA RUYLE

Art seems to be a spark of the eternal coalesced with a distinct historic moment,
driving artists to do something that witnesses their depth, that expresses
their most personal and universal insights.
—Alex Grey

Dedication

To the Circlemakers, with appreciation for the beauty they have added to the world
and for the awe they have inspired.

CROP CIRCLES
An Art of Our TIme

Mary Carroll Nelson

Publisher
Fresco Fine Art Publications, llc
Albuquerque, New Mexico
www.frescobooks.com

Printed in Italy

ISBN: 1-934491-00-4
978-1-934491-00-3
Special Edition ISBN: 1-934491-04-7
978-1-934491-04-1

Library of Congress Control Number: 2007928426

TABLE OF CONTENTS

CROP CIRCLES, AN ART OF OUR TIME

"As we enter the 21st century we are experiencing a moment of grace.
Such moments are privileged moments.
The great transformations of the universe occur at such time."
—Thomas Berry

Crop circles are a wondrous, creative anomaly in our time. Like living mandalas, these designs are discovered in fields of growing grain. Finding them is unpredictable, newsworthy — and mysterious.

LET US IMAGINE

Imagine a field of ripening wheat gently swaying in the late afternoon sunshine. The farmer gives a last look at the softly undulating hills. All is serene. He leaves for his home in the village. Late in the evening, it starts to rain. Early in the morning, the farmer drives again to his field. As the mist rises, he sees to his great surprise a three hundred foot wide, elegant fractal star formed by wheat bent down, swirled in clockwise and counterclockwise directions. The farmer shakes his head and murmurs, "What does it mean? Who did this?"

A VICARIOUS ENCOUNTER

In 1991, I had one of those fortuitous coincidences that come when you are "in the flow." Isabelle Kingston came to Albuquerque, New Mexico from England to give a lecture on crop circles. She is one of the most gifted spiritual mediums of our time. Her family descends from Edward III, Plantagenet, a king who was himself a gifted psychic. In each generation since his day, at least one person in the family has carried the gift. Isabelle is clairvoyant, clairaudient, precognizant, and a healer. She is also spirited and great fun. In her informative talk, she told us that true crop circles can be identified by certain characteristics that separate them from hoaxed formations. The following information is from Isabelle and other sources. Credit is also due to the www.cropcircleconnector.com website for some of these "peculiarities" of crop formations.

CHARACTERISTICS OF CROP CIRCLES

- Circles have appeared in barley, wheat, oilseed rape (canola), corn, oats, grass, rice paddies, trees (in Canada and England), sand, ice, and snow.
- Although predominantly in Southern England, they have been found around the world in grain producing countries, including more and more frequently in the United States, and also Canada, Australia, India, and Japan.

- Crop formations are made by the laying down of plants in a swirling manner, clockwise, counter clockwise, or radial. Sometimes, the spiral varies, layer by layer.
- Plants bend at their nodes, the hard, "fibrous protuberances" that help to support the stem, (Silva, 2002), without harm to the plant or to its flowers, even in the case of the brittle, thick stem of canola. Crops remain healthy and continue to grow within the formation. If the plants are still green, they will attempt to right themselves, but the pattern remains visible as they mature.
- A plant might refuse to lie down; at times single stalks remain upright.
- The edges of the crop formation are usually well-defined.
- When circles are first discovered, no human tracks lead in or out of them.
- Energy within the formation, detected by dowsing, is strongest at the nexus of the spiral, not at the geometric center. After harvesting is done, dowsing can still reveal the shape of the former crop circle. Each formation is different, with unique qualities. Even if the design seems to be a repetition of one formerly seen, its energies will separate the two.
- Crop circles are elliptical in form, rather than precisely circular.
- In association with freshly made circles, researchers have recorded a "trilling" sound that measures 5KHz. Some people can hear the sound without instruments.
- From the air, where the pattern is seen as if on a canvas, the formation shines like silk.
- Crop circles are often aligned toward sacred sites, such as Stonehenge. Or, they may be aligned with the "tram" lines that service the tractors when farmers spray their fields. These lines are thirty to forty feet apart. Formations are often sited near underground water and over chalk beds. Both water and chalk are good conductors of electromagnetic currents.
- Researcher Dr. W. C. Levengood, an American biophysicist, has subjected grain samples from the circles to analysis and discovered abnormal enlargement in the cell wall in bract tissue, "the thin membrane supporting the seed head," (Silva, Ibid. p. 135); enlarged plant stem nodes, which are distorted and stretched as if they had been microwaved; stunted seed heads; alterations in seed germination — either grossly depressed or markedly robust, whereas standing plants from the adjacent crop register none of these changes. (Nancy Talbot, Internet).
- Formations are most often made unobserved in darkness, but some have been made in daytime hours. Witnesses report seeing them made in speeds as fast as 15 seconds.
- Repeatedly, witnesses report seeing balls of white bouncing light associated with a forthcoming crop circle, or hovering over one that is already made.
- Anomalous electrical failures have been detected in or over crop formations. Cameras and recording devices have failed, and plane instruments have been affected, so pilots no longer fly directly over a formation.
- The shapes of formations have become increasingly complex. They appear to encode "sacred geometry," references to the diatonic scale in music, and advanced mathematical systems.
- Some persons who visit crop formations are sensitive to the energies emitted by them and suffer from headaches, nausea, tingling, dizziness, and a sense of lost time. Others have an opposite feeling of euphoria, exceptionally fine health, restoration, and affirmation.

Isabelle's slide show was the first time I had seen such a variety of crop circles. The range included geometric forms, calligraphic elements, echoes of

ancient symbols, and enigmatic patterns that imply meaning. A few of the designs looked like diagrams of machine parts.

They made two vivid impressions on me:
Crop Circles are a new art form;
Crop Circles are encoded messages.

After meeting Isabelle I felt compelled to go to England. In 1992, my husband Ed and I stayed with Isabelle in her 19th century landmark home near Marlborough in Wiltshire. Within an hour of our arrival, we were sitting in a crop circle dubbed "The Snail." Isabelle showed me how to dowse the energies in the main circle to locate the strongest energy at the nexus of the swirl in the flattened crop. The formation was more than a week old by then, but the pattern of the swirl was still amazing to me.

Isabelle arranged for us to fly over the fields with a skillful pilot named Rod who met us at a small airfield set on a grass-covered hill. In the luxuriously long twilight of July 28th, 1992, Rod flew the little blue plane, swooping and soaring while we stared in wonder at the famed downs of the Wiltshire countryside. Rod knew where each crop circle could be seen shining in the slanted rays of the evening sunset. One formation was that huge snail we had sat in the day of our arrival. Ed's photograph of "The Snail" is reproduced here and also in Linda Moulton Howe's book *Glimpses of Alternate Realities.* (Plate 2, p. 10)

In 1993, when Isabelle and her son Edward visited us, she gave a day-long workshop. She showed us 20 slides of distinctly different crop circles and asked us to choose which one was our "favorite." If we chose the same form we sat together to discuss what it meant to us. Finally, Isabelle interpreted each of the selected formations. Three of us chose a circle that included two crescents. She told us we were interested in restoring ancient wisdom, which was true. Another group picked

a design that looked like a cluster of snakes, or wiggly worms. Isabelle said that choice indicated a gift for healing. Almost every one of them was a nurse or therapist. The reader can enjoy a similar exercise at the end of this book.

We returned to England in 1995 and again stayed with Isabelle. I took a Celtic Odyssey Tour, hosted by Isabelle and Simon Peter Fuller, her business partner. A group of eight visited sites near Marlborough and Glastonbury. Isabelle secured permission for us to be in Stonehenge alone before dawn, so the tour group saw the sun rise above the stones.

On our last evening around midnight I was wakened by an exceptionally blinding light coming in through the window. An unmoving brilliant globe hovered in the near distance higher than the house. I was mesmerized by it for a long time and wondered if anyone else had seen it. The next morning, another guest was agog over it, thank heavens, because then I knew it was no dream. This experience of an unknown light is connected in my memory with Isabelle's home during a period of intense crop circle activity. The other guest was certain it was a UFO.

I have seen Isabelle on other occasions in the Southwest, both in New Mexico and Arizona. Our friendship has deepened, as has my connection with the crop circle vibrations.

On a third trip to England in 1997, forty-four artists, and spouses, who are members of the Society of Layerists in Multi-Media (SLMM) met in Marlborough to tour with Isabelle and Simon Peter. The tour group spent an hour in Stonehenge as the sun set and the moon rose, an unforgettably magical experience. Throughout the trip we felt the infiltration of crop circle energy seeping into our imaginations, but nothing was so penetrating as the visit we all made to the crop circle known as "Torus," a large central circle surrounded by narrow arcs woven across each other in a rhythmic pattern. I remember friends walking fixedly

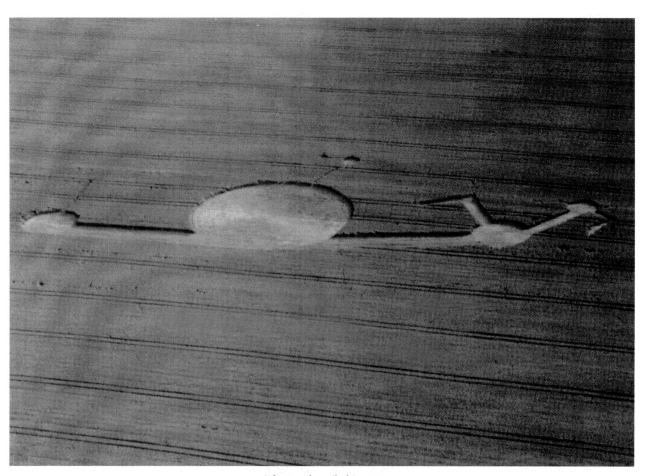

2. *The Snail* Wiltshire, 1992
Photograph by Edwin B. Nelson

within the crop circle holding bent metal rods and practicing the art of dowsing under the tutelage of Isabelle after Kingston, who is a master dowser, taught them the way.

A THEORY OF CROP CIRCLES

No one knows who creates crop circles but to me, they are art. I respond to this art as an art historian and as an artist. When crop circles are beautiful, I do not think it matters who is making them. The important fact is that they exist in real time – our time. The artists who are making them share their inspiration from the same source in consciousness. I believe the expanding field of consciousness research has a direct relationship with the art of crop circles. My explorations range through some of the discoveries in what might be termed the science of "quantum consciousness."

Crop circles are one of the signs that we are moving from an emphasis on linear thinking to a more holistic form of consciousness. What better symbol of a paradigm shift to holism can there be than a circle, so big and beautiful it cannot be ignored? The circle symbolizes balance and consensus-building. It refutes adversarial confrontation, authoritarianism, hierarchy, left-brain dominance, and patriarchal power systems. One interpretation of the circle might be this: in order to find global and fair solutions to the health of Earth and all of its inhabitants, it will be far better to form circles for discussion than to draw a line in the sand.

Crop circles are not scary. They are blessed. My book is meant to honor the art of crop circles as living symbols that will lead us toward our full potential as human beings.

Through the following text, I will place the burst of images in the fields within a context of many other developments in creative thinking that demonstrate an evolutionary leap in consciousness, from three-dimensional to multidimensional, at the very moment when we are moving from Earthbound creatures to cosmic explorers. We live in an extraordinary interface between the revival of ancient wisdom and an *opening to multidimensional human awareness.*

Following John Briggs' advice in *Fire in the Crucible, The Alchemy of Creative Genius*, that "by studying the part – any part – in depth, the whole can be known," I will approach the study of crop circles through "parts" that seem related to the subject. (Briggs, 1988, p. 72).

THE ART OF CROP CIRCLES IN THE HISTORY OF ART

Modern crop circles are an unprecedented art form that has a legitimate place in the endless flow of art history. Art is always an outgrowth of the time in which it is produced. In this book, I will attempt to define the art of crop circles as an expression of our present era.

Authentic modern crop circles are an art form created most notably by unknown Circlemakers in the fields of Southern England. They have spread worldwide. Although crop circles were known for centuries, the rich contemporary art form suddenly flowered in the late twentieth century. New formations appear in each growing season. Just as with other recognizable art forms, we can follow the development of crop circle art. The first stage was a long one, extending through centuries during which only simple circles appeared in the fields of England and elsewhere. The modern era of crop circles began around 1980 when the forms of the circles evolved from multiple circles to multiple rings, and gradually into advanced designs. (Thomas, 2002)

Today's circles are distinguished by complex patterns based, for the most part, on geometry. They are composed and executed in living plants or other natural materials on a grand scale. Every indication is that they are meant to be seen from the air, because it is

only from that perspective that the entire image can be appreciated. So, it is natural to speculate that there is a relationship between our ability to fly and the expansion of crop circle art. To that speculation we have to add the necessity for advancements in photography, because it is only through aerial photographs that the images of crop circles are available to the public. As we begin the twenty-first century, we are already in a period of post-classic crop circles, beyond variations on the circle to a period of zesty elaboration and growth in the art form.

Artists seek two goals: to express the emotion that inspired their work, and to communicate through their work with the viewer. The Circlemakers seem to be as committed to these goals as any artists in history. They are trying to express their personality as well as some kind of inner message.

We are accustomed to thinking of artists in terms of their style. Crop circles exhibit the marks of individual designers: there are those who prefer stark, sharply defined, bold shapes with an abstract Constructivist quality, like the geometric Russian art of the early twentieth century and others who delight in lyrical, narrow lines, with an Art Nouveau or Oriental aesthetic. Therefore, we can presume that a number of artists are creating the circles.

AN UNPRECEDENTED ART DEVELOPMENT

My speculations about crop circle art center upon their *timing*. Art history provides examples of the relationships between artists' works and their society. Art is, in fact, an index to its own time. The art of Ancient Egypt remained static for centuries. Status within the enduring Egyptian culture was highly valued and that fact can be detected by studying art from the period. Rather than a perspective indicating distance, artists of the Old and New Kingdoms depicted relationships of

scale – large figures were pharaohs or gods, small sizes indicated the peons who did their bidding. A similar emphasis on scale can be seen in Christian art from the Middle Ages.

The Renaissance occurred during the years of exploration, both in terms of ideas and literally by crossing the world. Linear perspective to suggest distance was perfected at the same time that European adventurers set sail for distant lands and brought back tales of wonders, new plants, and representatives of an exotic, unknown race. As Man became the measure of all things, the cognoscienti were attracted by the idealized, humanistic cultures of old Greece and Rome. Since Giotto in the fifteenth century, corporeal portrayals of the human body have been a valued subject in art. In the New World, as the idea of manifest destiny propelled settlers further West, landscape art that glorified nature became a dominant American art form.

Crop circle art is a unique expression of the present period that strides the "cusp" between millennia. Similar to digital art, which is also identified with this time period, crop art is a binary system. As a form of graphic design, it relies upon the contrast between light (positive) and dark (negative) spaces. Positive parts of the design are reflective shapes, created by forcing the plants to lie down. The darker forms are the parts where the grain is left standing. From the air, the flattened grain seems to gleam, especially in a wheat field under the slanting rays of late afternoon sun. Like other masterful designers, crop circle artists are not content to merely create a pattern. In addition to forming the light-reflecting portions of their designs, they embellish them by making complex weavings and setting out directional lines comparable to drawing strokes with a pen – except these linear refinements are not inked; they are done with stalks of living grain obediently assuming flattened positions that relate to one another in graceful arrangements. A digital artist

enjoys the benefits of bountiful color mixtures from an ink jet printer; whereas crop circle artists must rely on the color of the plants themselves. Fields of ocher wheat, brilliant yellow canola (oilseed rape) plants, and green barley furnish both the canvas and the pigment for crop circle art.

Artists are frequently ahead of their culture in sensing the leading impulses of development and change. Crop circle art is unique but it shares some inspirations with contemporary Earth Art by such artists as James Turrell and Andy Goldsworthy. In the past, large works made from the stuff of the Earth, such as Stonehenge, Silbury Hill, and the Pyramids of Egypt, Asia, and Mexico, were communal projects. Today, individual artists are organizing projects that involve moving soil, stone, ice, and leaves to stamp the world with their creativity, either briefly as with Goldsworthy or lastingly as with Turrell. These artists seem to respond to energies from within the Earth and they use the land as their canvas. A prompting to make art of the Earth has entered human consciousness and is playing itself out in related but separate forms of expression.

In the past, art was closely related to religion. Today, a search for a new spirituality is deepening our feelings for the Earth and our relationship to it. I believe that the picture of Earth floating alone in space is the icon of our incoming holistic world view. Once we saw that image, we began developing a heightened planetary awareness.

The twentieth-century was studded with dynamic new discoveries by physicists and mathematicians. Artists throughout the century expressed the same instinctual understandings as creative scientists did. (Shlain, 1991) Twentieth-century physicists established that the basis of the universe is a form of energy. We accept, at least intellectually, that matter is not really solid, but is comprised of space inhabited by vibrating and invisible elements of energy. In the twenty-first century, I theorize that we are destined to extend our comprehension into a range of unseen energies far beyond the third dimension of time and space.

In the new millennium, crop circle artists are, I believe, attuned to multidimensional information. Not only those mysterious Circlemakers who create "genuine" formations, but also the hoaxers, and other artists who are moved to "quote" crop circle images in their own work, are making signs that symbolize wholeness, a whole that includes more than the three-dimensional.

At the edge of speculative thought is the growing awareness that consciousness is the creative energy that powers the universe or universes we inhabit. Our consciousness is of a piece with this background cosmic consciousness. Crop circles are directing our attention to a holistic, multidimensional cosmic paradigm.

For five hundred years, linear thinking and reason have triumphed, rewarding us with an astounding level of technological progress and potential. We have been well-served by the commitment to a logical order of thought and we will continue to be, but as reason and intuition come into balance, probably for the first time in human history, we will truly be in a different stage of evolution. My central thesis is that the crop circles are timed to coincide with the dawn of the holistic age.

A PERSONAL CONNECTION WITH CROP CIRCLES

In the early 1980s, I read an article in a men's adventure magazine illustrated with photographs of crop circles with simple circular shapes. They dominated the land-scapes around them and they started a fire in my imagination. I looked upon them even then as a form of art.

At that time, I was writing frequently both for art magazines and art books. During a number of interviews with artists I was especially interested in their inspirations. Now and again, one of them would

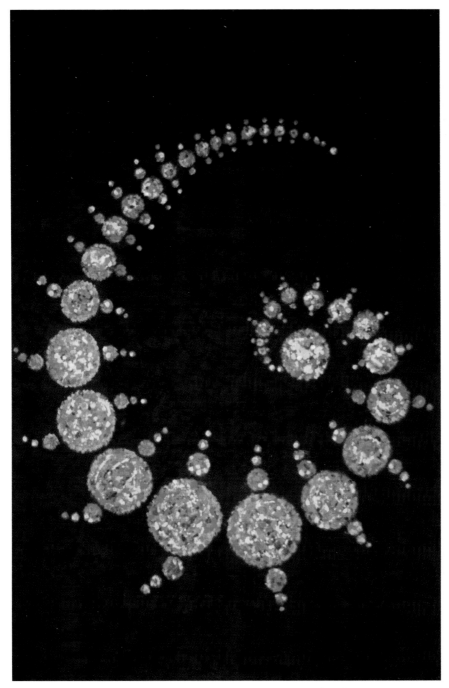

3. Lydia Ruyle *Stonehenge Julia* (Fractal) Handmade paper
Stonehenge, Wiltshire, 1996

answer probing questions about the meaning of their provocative work. They referred to psychiatrist Carl C. Jung's theory of the collective unconscious or Einstein's theories of relativity and the time/space continuum. Neither the artist nor I was well-versed in these specialties, but we were equally interested in them and had read about them as they filtered into the vernacular through secondary sources. It did not seem to matter that the work these artists did differed in medium and style. At root, their work had a subtle kinship and I was driven to explain their connection to myself. I felt a tremor of excitement because my own work reflects similar philosophical connections.

For several years I hunted for words in historical art writing that might describe what I perceived, but found nothing applicable. In the late 1970s, I coined the word "layering" to describe what these certain artists were doing. A layered work of art is filled with references to disparate ideas that are linked in the mind of the artist. I described Layering as a new development in art history. In 1982, my theory of Layering had matured to the extent that I founded the Society of Layerists in Multi-Media (SLMM) to serve as a network for artists who express a holistic world view.

John Briggs, speaking to a symposium organized by SLMM at the University of Texas Health Science Center in San Antonio in 1992 defined the holistic perspective as "a harmony in which everything is understood as affecting everything else." We have used his succinct definition in our application forms for years.

Once I had a language to explain what I observed in certain artists' work, I immediately began curating an exhibition of layered art that opened in 1985 at The Albuquerque Museum. By then, I knew that layering is a metaphorical process, a way to express connectedness across time and space. In early written material sent to artists, I included this explanation: "In layered art, many events connect at a single point in space; and many points in space are linked at a single moment in time."

Crop circles exhibit the same quality that I have defined in other art: they, too, are layered. One could say that to use the word layered in reference to them is a pun, since the formations are made with layers of grain, but it is not just the physical nature of crop art that is layered, it is the multiplicity of references they contain that reflects the same holistic philosophy that impels layering in contemporary art.

John Briggs illuminates the status of the artist as an agent who links the part with the whole: "...it is evident that the creator's task is very large. It is nothing less than the re-creation of the universe or, more precisely, finding or constructing a whole, integrated microcosm in order to reflect the whole macrocosm." (Briggs, 1988, p. 83). Both the crop circle artist and the Layerist deal with this large task.

Since 1985, I have met and interviewed several contemporary shamans and learned that they attain their wisdom through "journeying" away from themselves, out-of-body. From these interior journeys they bring back information they use to heal and teach others. Shamanic journeying is carried out in an altered state of consciousness that frees the person from daily life and allows him or her to travel through time and space, instantaneously. For this to be possible, there must be another, more fluid, reality that is available to consciousness. The universe we are in must be a continuous "layering" of realities of different densities in order for some portion of the shaman's consciousness to move through them without friction. (Nelson, 1994)

THE QUESTION OF HOAXES

"The reason we feel so passionately about the circles is that we know they are not all hoaxes," Isabelle has said. Each year, researchers devote time to testing which circles are hoaxes and which are "real," but Isabelle believes some hoaxers, especially the gifted ones, are unknowingly working for the Circlemakers –

the mythologized source of the circles. On a television program, an English youth explained how he gets designs in his head all at once, draws them on paper with careful measurements, and then goes into the fields and recreates them. The "design in his head" might, in effect, make the artist a vicarious agent of the Circlemakers. Although some circles are known to be man-made, they just cannot eliminate the fact that most crop circles are coming into the fields in a way that mystifies us.

From the ground, crop circle patterns are not discernible, but from the air, they dazzle the eye. Like any masterful work of art, they elicit sensual and emotional responses. Elegance, balance, intricate detail, sophisticated placement in relation to the surrounding landscape, and grand scale are aesthetic qualities almost uniformly found in these briefly glimpsed patterns. An inner geometry relating to sacred symbols characterizes the formations and gives them the claim to being a form of sacred art. Their appeal comes from the resonance we feel when viewing images from any period of art that incorporate the golden section. Derived from the Fibonacci sequence, the golden section is a proportion created by the division of a form into two parts, the relationship of the whole to the larger part is exactly the same as the relationship of the larger part to the smaller. The result is considered perfect harmony between elements in the composition.

If every crop formation ever recorded were hoaxed, the thousands of images appearing in cultivated fields would still constitute a great body of public work, some of the finest ever produced at such monumental size. Most researchers agree that a large number of circles each year are "authentic," i.e., not human-made. Arthur C. Clarke, in his television program on the crop circle phenomenon, asked, "Why aren't there more Englishmen whose backsides are filled with buckshot if they are out hoaxing these circles in the farmers' fields?" Clarke's question is apt. The fields of Southern England are under nearly constant observation in the spring and summer growing seasons by the curious and the researchers. It seems more and more unlikely that a team of hoaxers can go unseen during the hours it takes them to create a crop formation; whereas the unknown Circlemakers manage to leave immensely complex formations in the fields with nary a witness in most cases, and in markedly brief limits of time.

On July 7, 1996, an incident occurred that refuted efforts to trivialize the crop formation enigma. As reported that season in the *Circles Phenomenon Research International Newsletter* by Colin Andrews, "Light aircraft pilot Rod Taylor of Weyhill near Andover, Hampshire was flying a passenger over Stonehenge at 5:30 PM. They were looking intently at the dramatic scene of Stonehenge and its surroundings and are certain they could not have missed it (any pattern) had it been there." Andrews says that at 6:15 PM the former passenger saw a spectacular formation as he was driving past Stonehenge. Another account said it was the pilot who later drove by the field. Author Lucy Pringle writes that the formation was seen by a second pilot who flew over the field across the highway from Stonehenge. In the first report I received, the original pilot banked around Salisbury and retraced his route within a half hour and then he saw the pattern below. It was also said that his passenger, a doctor, made the sighting from the air. Andy Thomas, in *Vital Signs*, says the time frame was 45 minutes between the fly over and the return flight.

In every version of the story, within a short time of the original flyby there in the field was a spiral, 920 feet in length, and 500 feet in width, containing 151 circles (or 145, or 149 circles in various reports) forming a perfect illustration of the Julia Set, a familiar feature of the computer program that produces fractal patterns via mathematics. Just measuring the circles took the researchers the better part of a day. Not only was it a huge formation, but it was very complicated. (Plate 5, p.19)

Seemingly, the field was unoccupied yet the pattern appeared in broad daylight alongside a busy highway north of Salisbury. Quite soon, a traffic jam occurred there, as more and more drivers pulled over to look into the field. The farmer, who was dismayed by the intrusion of his field, changed his mind and charged each visitor two pounds for the privilege of looking at the spiral, thus repaying himself for the damage done to his crop by the large numbers of curiosity seekers who drove out to look at it. The Julia formation received a great deal of publicity for its size and the unexplained nature of its arrival.

In November, 2002, Dr. Chet Snow organized the "Signs of Destiny: Crop Circles & Sacred Geometry Conference," held in Tempe, Arizona. Francine Blake, a lively, winsome photographer and artist, gave a slide talk. She discussed in detail the fractal star patterns from 1998. From the ground, her photographs showed how unreadable the pattern was; yet from the air the star took on a three-dimensional form, created by the separation of values, lighter on one side of each projection, for example, and darker on the other. This made it appear as though the star was sculptural, rising and falling from point to point. Blake explained that the variation in light-emission from the flattened crop came from slight alterations in the angle of the individual stalks of grain. Those most perfectly flattened reflected as light areas, whereas those turned a few degrees more to the side seemed to be in shadow when seen from the air. This illusion was not dependent on the angle of the sun, only on the angle of the crop. As she finished her explanation, Blake in a high and amusing tone, said "Who would do that?" Indeed, in those few hours of darkness how could hoaxers possibly hand turn large areas of the crop without leaving their footsteps and without harming the plants in any way? (Plate 6, p. 22)

The whole subject of hoaxing has become much too exaggerated. When viewing many images of complex crop formations, one after the other, it is almost impossible to accept that they have all been created by human hands. Something about them seems to be "all at once," perfected in a single pass. I believe that the essential mystery of the crop circles is precisely that most of them defy duplication or imitation, although some are indeed hoaxed and some of these hoaxed images are art.

As a summation of the hoaxing problem, no one has expressed a more succinct observation than researcher Lucy Pringle who said, if just one crop circle is "authentic" — i.e., it was not made by a person, then the mystery of the formations is real and we must cope with it philosophically and scientifically.

THE JAW DROPPER

On the rainy night of August 12, 2001, the last visitor to Milk Hill in Wiltshire (a favored spot for observers to watch for crop circles) was driven from the hill around midnight by the rain. He returned at dawn and found a fractal spiral of 409 circles covering the top of the hill. It was 780 feet across. The August 24th issue of *Science* referred to it as a "Jaw Dropper," and ran its picture. A quote was included in the brief story that in order to have accomplished this formation a new circle would have been made every 30 seconds, because there were only four hours of darkness on that summer night. None of the hoaxers claimed it. Linda Moulton Howe reports that one of the hoaxers said it made his head hurt just to look at it.

Although the source of the circles remains an enduring question, I am captivated by the effects they have on our creative, absorbent minds. Mark Fussell, who co-directs www.cropcircleconnector with Stuart Dike, emailed this important observation: "People should pay attention to what goes on after the crop circles are made rather than focusing on what makes the crop circles. This is the way forward."

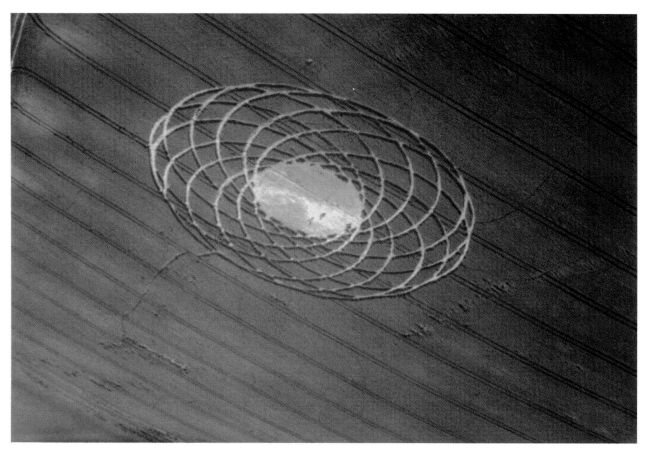

4. *Torus* Alton Priors, Wiltshire, 1997
Photograph by Mary Carroll Nelson

5. Lydia Ruyle *Out of This World* (Torus) Handmade paper
Picked Hill, Alton Barnes, Wiltshire, 2000

CROP CIRCLES, A MATTER OF CONSCIOUSNESS

"It is becoming clearer by the day that there is an inter-penetration of our existence with something of a Divine nature which may have a message to convey to us."

—John Haddington

The original and still most popular name given to the shapes in the fields is crop circles. Around 1980, there were only circles and rings in a variety of arrangements. More daring designs soon appeared. Rectangular bars, forks, irregular shapes, partial rings, crescents, and later symbolic renderings of mathematical theories marked the mystery with intelligence as well as intention. The most applicable description for this artwork is *agriglyph* — a symbolic image made in a field, usually from living plants. Agriglyphs are archetypal and they have a direct effect on our collective unconscious.

ISABELLE'S TRIADS

A synthesis melds disparate ideas into a whole. A triad is a synthesis that represents a stable combination, a sign of balancing. Isabelle Kingston intuits that the sources and meanings of crop formations are multiple and triadic. I outline two triads that she uses to describe aspects of agriglyphs. Her first triad has to do with their meaning. Some formations refer to *spiritual transformation*. Others are diagrams related to *propulsion*. Thirdly, some formations are references to *balancing feminine and masculine energies* within individuals and the human race as a whole.

Isabelle's second triad concerns the motivating energy behind the crop phenomenon. One element is the creative power of *human consciousness and subconsciousness*. The second energy is that of the *plant kingdom*. The third factor is the unknowable, which might be extraterrestrial or *interdimensional energy from the Sky Kingdom* responding to the intelligence streaming from Earth. Isabelle conjectures that when the three energies reach "critical mass" (a term that refers to nuclear reactors, now widely used to mean a sufficient number has been reached to create a specific effect), an agriglyph results.

THE PLANT KINGDOM

Since childhood, Isabelle has had a particular closeness to the plant kingdom, especially the devas or spirits of plants that she and other people can perceive. She emphasizes the role of the plants themselves in the creation of crop circles.

Brian O'Leary notes that laboratory experiments plainly show consciousness influences "the physical properties of anything 'out there' in the material world..." (O'Leary, 1996). Cleve Backster's work with the consciousness of plants, is described in *The Secret*

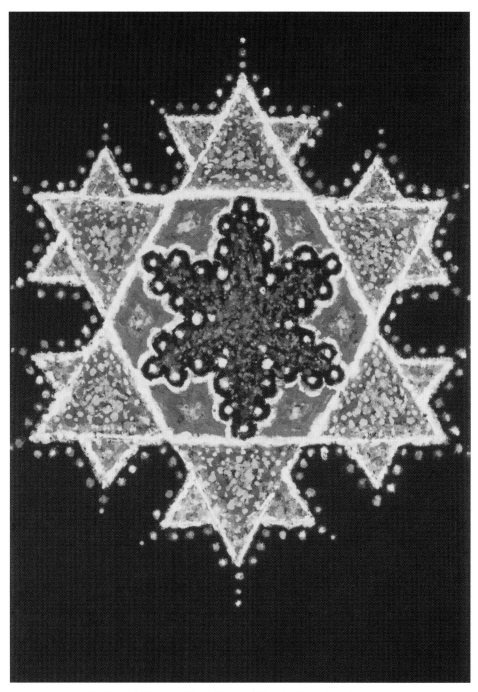

6. Lydia Ruyle *Koch Fractal* (Star) Handmade paper
Silbury Hill, Wiltshire, 1997

7. Lydia Ruyle *Galaxy 2001* (Jaw Dropper) Handmade paper
Milk Hill, Wiltshire, 2001

Life of Plants by Peter Tompkins and Christopher Bird. The book so deeply affected awareness that today praying over plants and talking to plants are widely practiced and are commonly expected to produce beneficial results.

Backster was an expert lie detector examiner. In 1966, on impulse, he attached electrodes to a dracaena, which is a tree-like plant with large leaves and clustered flowers. He discovered that the plant reacted self-defensively, as if in alarm, when threatened with danger or damage. Backster repeated his experiment over and over with all sorts of plants, even lettuce, and always he could detect surges of response when the plant sensed danger. He found that plants cooperated when treated with loving attention or "fainted" when faced with possible destruction, almost as though they were protecting themselves from awareness of pain. The plants displayed concern for their fellow plants by reacting to threats against them, also. Distance did not allay their reaction. Plants seem to be sensitive to some "unexplained medium of communication." Special plants became emotionally attached to Backster and displayed their awareness of his activities even when he was away on a trip. The reader is left with a profound sense of kinship with the green world. We are connected with the plant kingdom. Physicist David Bohm wrote, "...life itself has to be regarded as belonging in some sense to a totality, including plant and environment." (Bohm, 1980, p. 194)

Isabelle said, "I do believe there is cooperation between the Circlemakers — the devas, you might say — and the plants." She made another comment that brought a smile and stayed in my mind as a further link between us and plants. "Everything on this planet has a free will, including the plants. There is always one plant (in a crop circle) that is not going to lie down for anyone."

FINDHORN

The outstanding demonstration of working with devas and the plant kingdom is the famed Findhorn Community — founded in a caravan park along a fairly desolate shore in Northern Scotland by Peter and Eileen Caddy, with their three children, and Dorothy McClean in 1963. The enterprise was aided by the two gifted psychics in the group: Eileen channeled each night the information they needed for the immediate future; Dorothy McClean received guidance directly from devas, the spirits of nature in the garden.

Dorothy first made contact with the deva of the garden pea. She began directing questions to this deva, and Peter followed the guidance faithfully. He was told how to plant, how to nourish the plants, and how to "perceive the plants' true nature." Caddy always took a practical view of his available psychic guidance. "To create Heaven on Earth, as we were told to do, it was necessary to be firmly grounded in both worlds," he said. "True cooperation begins when we realize that man, the devas and nature spirits are part of the same life force, creating together." (Findhorn, 1968, p. 8)

Eileen channeled what she called the secret of creation. What you think, you create, was an underlying presumption of the Findhorn effort. The resulting prosperity of the Findhorn Garden was so eccentrically successful that seekers worldwide came to live there and the Findhorn Community was the result — an ever-changing population of sharing, spiritually-minded people. In this unpromising, dry and windswept soil, the garden produced sixty-five types of vegetables, twenty-one kinds of fruits, and forty-two different herbs. The plants thrived. Cabbages weighing up to 42 pounds vied with broccoli that was so large it fed the family for days. Eileen, the cook, spoke of her reaction to picking the food they had grown and preparing it for their meals. "I could see how alive everything was. I could feel each one of those vegetables

as a living being in my hands." (Findhorn, 1980, p.45) The tales from Findhorn were the first contact, vicarious though it was, that I had with the contemporary possibility of interacting with devas. They impressed me so much that I found the stories of crop circles entirely credible, from the start. *Crop circles might result from the interaction of human intention with the consciousness of plants and the plants' guardian spirits.*

In recent years, experiments have demonstrated that focused consciousness can influence crops in a field. George Wingfield tells the story that in 1991 six people meditated on a six-pointed form as they lay in a circle on the ground with their feet pointed to the center. The next day, in an adjacent field, a six-petalled daisy enclosed in a circle was found. (Bartholomew, 1991, p. 30) Linda Moulton Howe describes the actions of a research group who, on the evening of July 23, 1992, meditated on a design provided by the psychic Maria Ward who said she had received a mental impression of an isosceles triangle comprising three circles linked by straight bars. She felt that it had something to do with Cromwell. The next day a formation was found twelve miles away, just below Oliver's Castle, a site where Cromwell's army had fought a desperate battle. (Howe, 1993, p.24) My husband and I flew over the formation on July 28th and took our own photograph of it.

Did the plants "listen" to the minds of the researchers or did the Circlemakers direct energy into the plants through some other "medium of communication?" My thought is: *A dominant force in the creation of a crop formation is human thought transferred through telepathy to the plants with conscious intent.*

INTENTION

The intention behind a crop formation might be formulated at an earlier time than its appearance in the fields would indicate. Agriglyphs seem to carry potential energy that can be detected precognitively. In July, 1990, Isabelle predicted a formation would appear in a field below the White Horse at Adam's Grave near Alton Barnes, although no formation had been seen in that field previously. Not only was she sure a formation would appear there, she drew the pattern of circles, rings, a rectangular component, and protruding fork-like appendages that she visualized. Within the month, a formation, 184 yards in length, appeared in that field just as she had drawn it. A second one similar to it arrived soon afterward. The name "pictogram" was given to such extensive, complex formations. These two pictograms were so convincingly intentional and impossible to explain away that they hit the press across England and elsewhere as a genuine mystery. Isabelle's well-documented prediction established her as a world-class medium who is a reliable consultant about crop circles.

Isabelle does not say she provided the motivating intention for the pictogram that she visualized; she only says she was able to see it before it occurred. Therefore, it already existed *in potentia* and was accessible to her clairvoyant vision.

POSSIBLY: EARTH SPIRITS ARE BECOMING VISIBLE

Some people have such heightened visual abilities they can penetrate the veil that encapsulates our dense three-dimensional reality. These see-ers perceive the filmier, thinner dimension where live the Little People. All over the world there are stories of fairies, devas, sprites, elves, gnomes, leprechauns, pixies, peris, and menahunes. Our gifted see-ers tell us that there really are spirit creatures living alongside us, just as we have learned from our myths. Legend, we continue to discover, is a prime way of recording history. I speculate that at one time the ability to see into a different reality

was more common than today. I also believe the talent for seeing into a less dense, nearby dimension is reawakening in the human race.

Dorothy McLean said, "The devas hold the archetypal pattern and plan for all forms around us, and they direct the energy needed for materializing form. The physical bodies of minerals, vegetables, animals and humans are all energy brought into form through the work of the devic kingdom... While the devas might be considered the 'architects' of plant forms, the nature spirits or elementals, such as gnomes and fairies, may be seen as the 'craftsmen,' using the blueprint and energy channeled to them by the devas to build up the plant form...Essentially, the devas are energy, they are life force."

Devas and other nature spirits have no material form. In a passage channeled from the devas and recorded by MacLean, the words come close in spirit to theoretical physics: "We work in the formless worlds and are not bound or rigid in form as you are. We travel from realm to realm and are given wings to denote this movement. As we travel, our form changes... We deal directly with energy and that energy shapes us, is part of us, is us, until we breathe it out to where it is needed. We are limitless, free, and insubstantial." (Findhorn, 1968, pp. 54-59)

STRANGENESS

Researchers, using conventional methods of scientific inquiry, have made valuable contributions to the study of crop circles. They have measured, taken ground and aerial photographs, dowsed the circles, used electronic sensing devices, and carried out experiments to contact the Circlemakers, which other writers have discussed sequentially and in detail. I am not persuaded that the enigma of the crop circles will be solved by these methods, although the data amassed by them is impressive.

Over time, a generally held conclusion has been reached that a creative intelligence is behind the mystery. To penetrate that creative intelligence will require more than measurements. Whoever is conceiving the formations thinks like a visual artist, but there are other concepts expressed in the formations besides artistic principles. Musical structure, mathematics, engineering, and psychology, mythology, and spiritual traditions are alluded to in the designs. They suggest synthesis on a grand scale. Assuming the agriglyphs represent metaphors for thought, we have to stand back in wonder at the density of their possible meaning.

The Circlemakers display humor as well as intelligence. "Someone, somewhere, is listening to what we're saying," Isabelle quipped. As researchers desperately hunt for generalizations that will describe and limit this ongoing phenomenon, the Circlemakers respond to almost every suggestion in contrary fashion. Soon after the theory was published that circles appear at the base of hills, they began appearing on flat fields. People noticed that circles were aligned with the tram lines used by tractors for periodic spraying, but soon circles appeared that were unrelated to such grooves in the crops. When it was recorded that crop formations spiraled in a counterclockwise direction, circles appeared with clockwise spirals, and multilayer spirals each going in a different direction, or in sunburst patterns. When whirlwinds were credited as the cause of the early circular formations, straight avenues, boxes, triangles, and forks appeared. If we could only hear it, the cosmos must be filled with laughter.

Lights associated with crop circles seem to react to human consciousness. During an experiment conducted in 1992, researchers beamed powerful lights into the sky in a rhythmic pattern. Above the horizon, orange lights responded by blinking in the same sequence. Little lights bouncing in the fields where crop circles appear, both at night and in daylight, have been captured on film by Steve Alexander and others. The

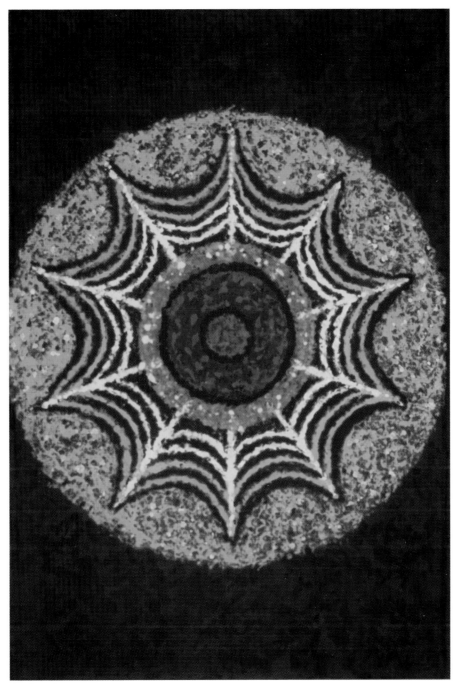

8. Lydia Ruyle *Grandmother Spider Woman's Web* Handmade paper
Avebury, Wiltshire, 1994

intense lights do not seem to grow smaller when they move away from the camera. Once, as Alexander was photographing, he noted that a farmer on a tractor stopped as the light approached and started again as the light moved away. When he checked with the farmer, the photographer found that the tractor had stopped of its own accord. Even hoaxers say that they are visited by little lights when they are carrying out their fraudulent enterprises at night.

Circles have appeared whose dimensions match almost exactly those of Stonehenge, giving rise to the notion that the original henge was built as a tribute to an ancient circle. Dowsing patterns in these crop circles echoed those from Stonehenge — an indication that the shape relates to energies contained in it.

Later additions to an extant circle are not uncommon. In 1994, a design of slender scalloped lines enclosed in a circle appeared beside Avebury. A day later, observers found that connecting ray lines had been added so the formation resembled a spider web. The spider web has associations with the inner structure of Silbury Hill, seen in cross-section. The form is a reminder that among Native Americans the geniatrix of life is Spider Woman. (Plate 8, p. 27)

Albion, the White Horse, is a symbol of England. Early people believed the White Horse came from the sky and is a messenger between heaven and earth. This belief in the horse as sky messenger is held all over the world by native people. Of the six White Horses cut into the chalk cliffs in various sites within easy reach of Marlborough, the abstract, modernist White Horse at Uffington is the most ancient, approximately 4,500 years old. Circlemakers make no distinction, however, between it and more recent horses. All of them attract crop circles. A huge formation was found below the Hackpen (Snakehead) Hill White Horse in the summer of 1995. In June of that year, near the Cherhill White Horse was a nine-ringed formation resembling a diagram of the solar system with its planets.

THE POWER OF SHAPE AND SOUND

Crop formations are spreading around the globe. They are found in the United States, Canada, Australia, New Zealand, Europe, Russia and other grain-producing countries. They have been seen on ice too thin to support human weight. In a Moscow city park, circles of depressed deep snow were found without footprints in any direction. Detectable electromagnetic energy was recorded there. Circles, drained of thousands of gallons of water, have occurred in the rice paddies of Japan. (Japanese have investigated English agriglyphs in the belief that tappable energy might be found in them.) Fully grown trees bent into a spiraling circle have been seen from the air, one in the fir forest of Canada and another in New Forest south of Salisbury in England.

Crop formations indicate that their shape has energy, in much the same way that a pyramid has power. A pyramid does not have to be solid for it to be effective. Constructed only of dowels, a four-sided pyramid made to the same scale as the Great Pyramid has the power to preserve foodstuffs.

Researcher Colin Andrews reported in his newsletter (*Circles Phenomenon Research*, Spring/Summer, 1995) on an experiment conducted in the Great Pyramid, with permission of the Egyptian government, by Dr. Jonathan Sherwood, an archaeologist from Australia who believes that "all ancient sites are interconnected by a grid of electromagnetic energy. Changes in one site affect all the others."

Dr. Sherwood "discovered that the dimensions of the three chambers, when directly related to sound frequency, have harmonic relationship to each other and produce frequency nodal points. These nodal points are crucial to his research as apparently very strange effects are associated with them."

Andrews heard Sherwood describe his experiment. As varying sound frequencies were transmitted within the main chamber, "all 54 people present witnessed the

materialization of an additional human form which proceeded to move through the walls of the chamber as if they were not there. Shortly after this occurred, stones at the nodal points began levitating." On exiting the pyramid, the guide noticed a series of dots formed in four rows on the pillar beside the entrance that were not there when they entered.

Dr. Sherwood, Andrews writes, is convinced that the mathematical equations discovered in the great pyramid also relate to the crop circles. He believes that the sound frequency applied to the harmonic nodal points within the chambers had caused previously conditioned effects to manifest. Should his theory apply to crop circles, it suggests there is a latent pattern in the fields which is activated by sound frequencies, causing the crop to lie down.

Freddy Silva refers to an idea given to me by shamans I have interviewed who say that the Earth is undergoing a rising frequency in its vibrational rate. This thought brought Silva back to the trilling sound noted by sensitives in a fresh crop circle. "The musical scale, constructed on the harmonics of sacred geometry, and now found within the framework of crop circles, represents the mathematical structure of the soul of the world because it embodies the essence of the universe modeled on it," he writes. Concurring with Isabelle, he says, "...show people a mere photo of the real thing (genuine crop circle) and their eyes light up, they become emotional, light-headed, ecstatic, benevolent, dizzy, even noxious." (Silva)

Fred Alan Wolf studied with native shamans in an effort to distill the physics behind the powers they have acquired. In this process, he himself went through initiation. Among the subjects in his book *The Eagle's Quest* is "projective or sacred sound" which he learned in his work with Carlos Suarés. "When these sounds were pronounced, a resonance of some kind would occur and the speaker would be in 'tune' with the universe...These sounds were able to change matter."

(Wolf, 1991, p. 44) Wolf's account reinforces the possibility that sound affects the grain when an agriglyph is formed.

Wolf also writes that certain stones are radioactive and emit signals; he theorizes that during the late Neolithic period shamans were sensitive to the stones and their energies. He learned that certain plants only grow in specific areas and there is an implied interaction between the "subtle fields"of plants and the energies of the sites where they grow. His investigations related to psychotropic plants, but his idea could have wider application. If the plants and their sites are in relationship in terms of their energies, that might account for one aspect of the collaboration necessary to produce a natural crop circle. By "natural" I mean a formation that is not manmade. (Ibid. p. 107)

JUNG'S RESPONSE TO CIRCULAR UFOS

The basic circular shape which is the most frequent component of an agriglyph is a form shared with UFOs. In his extended essay *Flying Saucers*, Carl G. Jung wrote, "I'm puzzled to death about these phenomena..." (Jung, 1956, 1978)

Jung's interpretation of circular UFOs could be applied to circular crop formations... "Concerning the essential weirdness of the Ufo (sic) phenomenon, we cannot expect the familiar rationalist principles of explanation to be in any way adequate."

Before his death in 1961, Jung studied many reports of UFO sightings and also dreams of UFOs among his patients. Luckily, he was Swiss so his access to reports was uncurtailed by the curtain of secrecy that had already fallen over the UFO mystery in the United States. As a psychiatrist, not a physicist, Jung concentrated on the psychic aspect of UFOs and focused on the circular shape in particular. He compared it with a mandala, a symbol of totality.

"The apparently physical nature of the UFOs creates such insoluble puzzles for even the best brains, and on the other hand has built up such an impressive legend, that one feels tempted to take them as a ninety-nine percent psychic product..."

Jung suggested that UFOs might be a projection, a manifestation of the unconscious, a "rumour," a vision, an archetypal image, or a symbolic representation of the self. He traced the mythological connotations of a circular form as nurturing, feminine, widely distributed, and exceedingly ancient. He came to no conclusion about the reality of UFOs though skeptics often quote his essay to portray UFO sightings as figments of active imaginations.

Jung did not live to see man walk on the moon or images relayed from Mars by our space probes, so he spoke of man's fantasies about space travel as a desire to be rescued from the skies; but he had the humility to speculatively ask, "...why should not more advanced star-dwellers have discovered a way to counteract gravitation and reach the speed of light, if not more?" (Jung, 1978, p. 23) He granted that the discoveries by physicists made things seem possible that not long before would have been thought "nonsensical."

A MATTER OF CONSCIOUSNESS AND....

Consciousness is about being aware. I believe that crop circles are telling us to be aware of them because they are holistic signals of a new way to think. Crop circles are geometry writ large in the fields. They exemplify mathematical relationships which can be analyzed. It is also true that they are metaphors for music. Another truth is that they are geomantic because they are found near sites with special energies and ancient meaning as sacred places. They seem to be related to UFOs and bouncing lights in the fields. We can say "Yes, some of them are manmade and others are not." All of this is true, which means crop circles are a perfect example of a holistic phenomenon. To discover their meaning, we look upon every contribution from every researcher and devotee – and each of them has a portion of truth in them. If we assemble these portions of truth, we come up with a whole greater than the sum of its parts.

THE TURNING POINT

The 'genius' code now being activated is the pattern or imprint
for our next developmental stage as we evolve from
homo sapiens to homo universalis – the Universal Human.

—Barbara Marx Hubbard

Whatever they are, whatever they mean, crop circles are potent signifiers of transformation at a crucial moment in human development. Fritjof Capra has called our time "the turning point" when we are witnessing a shift in accepted scientific premises. (Capra, 1983) Willis Harman, a philosophical observer of science, identified the in-coming model of the universe that underlies science as a new "metaphysic." The real world of matter exists, he said, but it is held within a dream that obscures another dimension. In his words, "there appears to be a reality behind the physical world that modern science, in its present form, is in no position either to affirm or deny." (Harman, 1988, 1998)

I propose here that crop circles are an outward sign of this other reality — and a contributing factor in the transformation now occurring. As a human race, we are becoming aware of the limits to knowing through reason alone. Theoretical physicists, medical investigators, and society's observers are moving toward a holistic way of studying the world around us. Antoine Faivre, in an interview with Gary Lachman, explained his own exploration of this more esoteric tradition. "I call it a form of thought," he said. (*Quest*, May-June, 2000, p. 91)

Whole areas of our experience, unexplainable in the strictly rational terms of traditional Western science, are better approached by this other form of thought. We look to science as a source of truth and we can verify by the superb technology of our material world that science has been amazingly accurate in its assumptions — but, beyond traditional science is the private world of mystical moments, blissful epiphanies of connectedness with God and the universe, or split seconds of unconditional love. The continuous replenishment of creativity, the anomalous wisdom of shamans, worldwide sightings of UFOs, unexplained cases of spontaneous remission, improved health as a result of prayer, psychokinetic effects, precognition and spiritual mediumship, telepathy, and remote viewing all speak to us of consciousness and the power of mind. None of these demonstrable aspects of the human experience fits well into the scientific methodology whose principles are objectivity, positivity, causation, and particularly, reductionism in which complex problems are solved by reducing them to their component parts. Increasingly, we are discovering that we must study the whole rather than the parts. Our universe is composed of inter-related and interdependent entities that do not function in isolation.

Crop circles have kinships with other anomalies, especially those having to do with creativity and aspects

of mind. They fit in a cluster of signifiers whose emergence in the last century pointed toward a heightening of consciousness which is accelerating today. I believe that the energy and shapes of crop circles can trigger changes in consciousness and that they are a deliberately timed and necessary aspect of a leap in human evolution. Through altered states of consciousness, aided by hypnosis and electronic recording devices, we are confirming the survival of consciousness and projecting that it precedes and outlasts what we know as "life."

OUT OF BODY EXPERIENCES

As our medical technology has improved, more people have been resuscitated from a Near-Death Experience. Certain visionary characteristics of an NDE have been studied and codified. Subjects describe their experience as detached from ordinary reality. They feel they are literally out of their own bodies, ascending and looking down on themselves, able to see and think. Later, they remember witnessing the activities and hearing the words of those who attended them. They might find themselves flying away from the site of their body to other locations where they are again able to accurately witness events.

The late Robert Monroe, founder of the Monroe Institute in Virginia, taught clients how to initiate an Out of Body Experience. "One key element repeated consistently, the subjects located within their nonphysical perception a pinpoint of light," Monroe wrote. His subjects learned to move through the light as it expanded. The experience of leaving their body with conscious awareness and memory gave them a certainty that they are more than their body and that there is life beyond death. (Kenneth Ring, 1984, 1985) and Robert Monroe, 1977, 1985)

DEATH

Everyone eventually loses loved ones. After their death, many survivors have sensed their on-going presence. Objects move. Sounds occur from no detectable source. The temperature drops suddenly. Aromas associated with the departed fill the room. Since affected witnesses may have no proof of these events, their reports can easily be dismissed as delusional, or at best, merely anecdotal. Spiritual mediums can perceive discarnates in their ethereal bodies; but a medium's perceptions vary from acute to poorly developed, which makes it difficult to conduct controlled studies of their ability to "see beyond."

Dying has been the great taboo subject in our Western society. Our entertainment media serve continuous images of death to audiences who are avid for them, but as a culture, we have no consensus about the nature of the experience. At the same time, there is a growing body of information about death based on repeated observations of those who die under medical supervision. The classic study by Elisabeth Kübler-Ross, M.D., *On Death and Dying*, makes death familiar and conveys a sense of release and peace. As a result of Western investigations conducted over a period of time, information about death is making its way into the minds of more people and death is becoming less dreaded.

MARK MACY

Studies of death and beyond demonstrate that reality includes more than the familiar three-dimensional world of space and time. In the last century, new ways to penetrate the veil of death have evolved along with the development of electronics. Mark Macy, in Boulder, Colorado, and a global network of people have conducted "Continuing Life Research" via tape

recordings, color television, computer, and telephone, combined with telepathy. They have accumulated recorded responses and two-way communication, even with color, to and from non-physical beings, that offer convincing evidence about the survival of consciousness after death. The experimental effort to achieve communication across the barrier of death originated with Edison, Tesla, and Einstein who believed it would become possible once electronics were advanced sufficiently to transmit and record exceptionally high frequencies beyond the grave. These men of genius are now among the discarnates who communicate data to researchers, and their continuing advice has proved valuable in refining electronic gear used in the process. A computer message received from a former colleague, now deceased, was quoted in Macy's newsletter *Contact!*, January-April, 1998 issue: "Here on Marduk I found what is generally referred to as 'happiness.' ...I want to pass on the message that life is indestructible." (Marduk is the name given to the "planet" on which these discarnates find themselves after their deaths on Earth.)

During a colloquium held in Chicago in 1994, Willis Harman spoke in support of Mark Macy's work. Harman was president of the Institute of Noetic Sciences, sponsors of the event, and he was an influential thinker. To an audience of 1700 people, he described death as a continuation of consciousness. Since Harman's death, Macy has had contact with him. I find it particularly touching that Harman revised his important book, *Global Mind Change*, from which the following quote is taken, when his own life was so soon to end. (Harman, 1998)

> When the soul is ready, learning resumes; the journey to greater awareness continues. Our consciousness is of the same quality as that which pervades the universe...Learning does not stop with the death of the body; the path to higher awareness is never-ending.

Ian Stevenson, a respected parapsychologist at the University of Virginia, has devoted himself to searching for evidence of reincarnation. His data compiled from cases in this country and abroad support the widely held belief that consciousness continues from life to life. From both personal experience and experimental study, Raymond Moody has also found evidence for *Life After Life*, the title of his famed book. (1976)

The gifted medium, Edgar Cayce, while in trance, connected with events and persons who were distant from him in space and time while he was in a trance state. He quoted from the Akashic Records, a term in Eastern lore which denotes an eternal data bank of material about earthly inhabitants, their lives, and physical characteristics. Cayce crossed between dimensions over and over again in his quest for information to help heal others.

BRIAN L. WEISS, M.D.

Dr. Brian L. Weiss, M.D., Chairman of Psychiatry at the Mount Sinai Medical Center in Miami, Florida, used hypnosis to help his client, Catherine, deal with anxiety. Catherine went deeper and deeper into relaxation as Dr. Weiss regressed her into memories of her childhood. He was stunned when she began to whisper about another life she lived a hundred years ago. Catherine not only recalled many prior lives, but she also described her experiences as a soul between lives. Besides her memories, she brought messages from a Master Spirit who claimed that the spirit world is the natural home of our souls. Weiss was transformed by Catherine's revelations. He writes:

> "...I straddle two worlds: the phenomenal world of the five senses, represented by our bodies and physical needs; and the greater world of the nonphysical planes, represented by our souls and spirits. I know that the worlds are connected, that all is energy." (Weiss, 1988. p. 209)

MICHAEL NEWTON, PH.D

Dr. Michael Newton, Ph.D., a psychologist, has explored deep memories of prior death experiences in many subjects through hypnosis and reported excerpts of their descriptions in his books *Journey of Souls* (2000) and *Destiny of Souls* (2002). After several clients spontaneously slipped into a superconscious state and spoke of soul life between lives, Dr. Newton devised a prolonged and intense hypnotherapeutic technique. "I place the client in hypnosis very quickly. It is the deepening that is my secret. Over long periods of experimentation, I have come to realize that having a client in the normal alpha state of hypnosis is not adequate enough to reach the superconscious state of the soul mind. For this I must take the subject into the deeper theta ranges of hypnosis." (Newton, 2000, p. 9) Dr. Newton's transcripts of nearly 100 cases create a vivid picture of the spirit world, almost photographic in its details. The reader becomes familiar with a benign, conscious and interactive post-death soul life. Dr. Newton's subjects have told him that just after their deaths they tried to contact grieving loved ones.

INDIGO CHILDREN

A group of children, worldwide, who have been born since the 1970s, are referred to by some as the "Indigo Children" because researcher Carolyn Jantow noted this color in their auric field. They have discernible characteristics that could be considered evidence of master souls. Sometimes referred to as Psychic children, or Crystalline Children, they are born with an understanding of Oneness. Many of them have psychic and telepathic ability. Some have suggested that incoming children have genetic changes in their DNA structure and digestive systems, and they seem to be using areas of their brains that their forebears did not.

The old ways of thinking, governing, and interacting do not harmonize with these children who are wiser than their parents. They need choices, not directions. The Indigo Children are "system busters" who are highly creative, compassionate, determined, focused in the now, and independent. The elders must learn to work with the Indigos. It will not be the other way around.

The description of the Indigo Children resonated with my experiences as a teacher. Their arrival plus the discoveries of our "pre-life/post-life" spirit states made by Dr. Weiss and Dr. Newton and others reinforce my belief that our species is in transformation. We are gaining access as a species to a broader range of consciousness.

TOWARD HOLISM

The riddle of the crop circles lends itself to a holistic approach. Because crop circles can be viewed as evidence of multidimensionality, they appeal to the same holistic inclination that leads to Layered art. The ultimate model of holism is the holograph in which the part reflects the whole. Shamanic thinkers agree that we ourselves are reflections of the sacred wholeness that constitutes the universe. Jeffrey Mishlove, founder of The Intuition Network and host of the PBS program *Thinking Allowed* said in a lecture that each of us has a "divine spark" within us. The divine spark is that part of us which is reflective of the whole. The answer to anomalies and most other mysteries must lie in the field of a multidimensional wholeness that we are just beginning to explore — yet it has been affirmed for centuries as the "perennial wisdom."

The study of paranormal events falls outside the normal "box" of science. Dr. Brian O'Leary surveys the state of explorations beyond traditional science. He lists crop circles among the anomalies worthy of study by "New Science." Willis Harman wrote this blurb for

O'Leary's first book, "It is...an appeal for a more open and extended inquiry — into some of the remaining mysteries of outer space, including indications of past and present non-human intelligences, and also into the eternal mystery of the mind within." (O'Leary, 1989)

In 1994, I organized a symposium for SLMM and the public in Fayetteville, Arkansas, based on my book *Artists of the Spirit*. One of the subjects whose story I tell in the book is Barbara Hand Clow. She spoke to the audience on the multidimensionality of consciousness, especially the activation of other dimensions of consciousness during the creative process. In setting the stage for her descriptive talk, she mentioned that birds and other animals are more multidimensional than humans. They move in and out of our reality depending upon our receptivity to them. Her words gave me a sense that the animals who are considered extinct are still alive, but they exist in a different dimension from ours.

Clow illustrated her central thesis by leading us on a guided meditation as she described the experience of her friend, an abstract painter, while she created a painting. As she led us through the stages of consciousness into the flow of creativity through ascending dimensions of reality, and then down again into our normal everyday awareness, I — and all the other artists in the auditorium — felt a kinesthetic identification with the alterations in consciousness that her friend was undergoing. Barbara believes many of us, particularly artists, are already moving easily into the fourth dimension of timelessness that separates us from ordinary reality. Beyond timelessness is the formlessness of the fifth dimension, which Clow says is the geometric level.

The artist undergoes a "layering of realities" and it constitutes a doorway into another reality. All artists aspire to these moments of "flow" with the creative source. Artists who are working with formlessness at the fifth dimension are, paradoxically, also at the geometric level in Barbara's model, and they are attempting to make formlessness visible.

Crop circle artists are demonstrably working at the geometric level and they are signaling to us that we are "wired" to claim higher reaches of awareness if we so choose.

CROP CIRCLES AS HOLISTIC SIGNS

José Argüelles has described symbols as "the cosmic language, the language of cosmic laws" that were known eons ago and are now returning. (Argüelles, 1989, p. 68) The research data bank on crop circles shows that familiar symbols, such as the Eye of Thoth, the sign of infinity, the spiral, the serpent, the scorpion, the Goddess, and the triangle are showing up in the fields. Gregg Braden has done an excellent job describing the "languages" of crop circle symbols: sacred geometry, genetics, electrical circuitry, mathematical symbols, and sacred symbols of the elders of the Earth. (Braden, 1997) *The symbols that are emerging as crop circles are signals, I believe, to our unconscious selves, reminding us to remember to be aware of our Oneness with nature.*

One premise of this book is that a vicarious contact with crop formations, via aerial photography and artwork, has the power to excite the viewer's imagination. Among those affected by these images will be people who are "wired" to recognize them. Some formations seem to stimulate a subtle healing energy, or a feeling of balance and well-being. The shape itself might energize creativity by supplying the design of a missing piece of an invention already in process. Some of the crop formations definitely resemble mechanical diagrams. The American author Doug Ruby was inspired by two-dimensional photographs of crop circles to render then as three-dimensional models. His meticulous work is recorded in *The Gift, The Crop Circles Deciphered*. He indeed created a gift for his readers who can visualize the possibility that we are being given instructions for building new tools and craft.

Something is afoot. Because crop circles are so overt, so hard to ignore, I think they contain information that we are expected to grasp. Linda Moulton Howe introduced her book *Glimpses of Other Realities, Vol. I: Facts and Witnesses* with the words, "In these glimpses of other realities, a new cosmology is emerging, a different understanding about who we are, how the universe works, and how human consciousness might contribute to its spiralling evolution." (Howe, 1993, p. xx)

Willis Harman compared the present state of science with the original Copernican revolution that reordered our concepts of outer space. "This one," he wrote, "is concerned with our understanding of *inner* space." (Harman, 1998, p. 33) Brian O'Leary has made a similar comment, "I believe we are entering a Consciousness Revolution, based on an emerging sacred science, which has far greater implications than anything we can imagine." (O'Leary, 1996) Leonard Shlain expresses a related thought in *The Alphabet Versus the Goddess*, "I am convinced we are entering a new Golden Age — one in which the right hemispheric values of tolerance, caring, and respect for nature will begin to ameliorate the conditions that have prevailed for the too-long period during which left-hemispheric values were dominant. Images, of any kind, are the balm bringing about this worldwide healing." (Shlain, 1999, p. 432)

Crop circles are images that promote a revolution in consciousness. I sense that we are being prodded by these beautiful signs in the fields to transform interiorly in order to further our own evolution. By writing about them in their context as art and as sign, I hope to assist in the transformation that is underway.

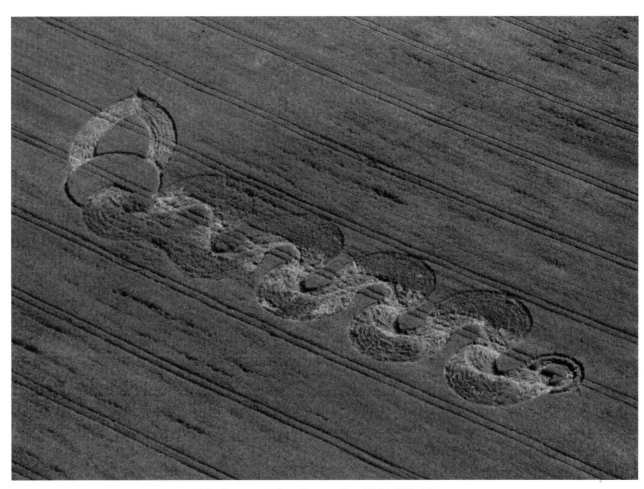

9. *The Serpent* Alton Barnes, East Field, Wiltshire, 1999
Photograph by Steve Alexander

A MULTIDIMENSIONAL, CONSCIOUS UNIVERSE

*"Realities are layer cakes and only multidimensional models
will describe anything real."*

—Barbara Hand Clow

"Consciousness was present from the first instant at the Big Bang."

—*David Bohm*

THE NOOSPHERE

Teilhard de Chardin posited that the noosphere is an Earth-sphere, an encircling envelope of thought akin to but separate from the biosphere. (Chardin, 1955) It is the repository of current, past, and future thought. We all share in this noosphere, giving to and receiving from it. In this way, we are all agents of thought.

Writers are among those who deliberately deposit information in the noosphere. A published idea enters the minds of readers, who may think about it themselves, give more energy to the idea, and let it move from them back into the noosphere where it will flow into the collective unconscious or conscious minds of other human beings. Thus, books, television, films, the Internet, and radio are channels in the flowing current of the noosphere.

In reviewing the books I feel are pertinent to the synthesis I am making, I realized that most of the authors I find instructive are also creating a synthesis by drawing upon other authors before them for elements to amplify their own thesis. Their process and mine have been the same, each writer makes the selection of references that reflects decidedly personal intentions. When I thought more about this collecting and layering of thoughts to create a work that is more than the sum of its parts, I could see that it is a metaphor for the noosphere. As each of us draws from it and adds to it, we create patterns of thinking. All the patterns taken together form the circulating wave of thoughts that constitutes the noosphere.

A WATERSHED OF CHANGE

So many synchronicities are involved in the consciousness revolution that it seems to be orchestrated. The noosphere is throbbing with an in-rushing apprehension of profound change. Mystic shamans and scientists alike are saying we have come to a watershed in time.

Thomas Berry writes, "After some four centuries of empirical observation and experiment we are having a

new experience of the deepest mysteries of the universe...We find ourselves living less as cosmos than as cosmogenesis. In this context we ourselves have become something of a cosmic force." *Spirituality & Health*, Winter, 2000).

ON THE EDGE OF CURRENT THOUGHT

A changing group of sages appear together as symposium speakers and in recorded conversations with one another. The outburst of symposia, bringing together major intellects for discussion on edge topics — usually a synthesis of subjects such as Science and Spirituality or Spirituality and Healing — has sprung up only in recent times. They are a popular means of spreading ideas through the society, even though they are expensive. A process akin to osmosis has had time to establish itself within the world of symposia. From the point of contact between acolytes and gurus, an updated perennial wisdom filters outward. The apostles move back into their daily life carrying the seed of a holistic world view promulgated at the conferences. Thus, in effect, a field of influence is created that includes those who deliver the ideas and those who resonate with them. I include myself among the resonators. I have organized several conferences, attended others, and ordered tapes from those not attended. In this way I have developed vicarious relationships with many of the major thinkers who are contributing to an expansion of consciousness. There is a shared philosophy emanating from symposia. Among its tenets are:

- All is One. Everything is connected.
- The model of the universe is a hologram in which the part reflects the whole, but the whole is greater than the sum of its parts.
- We are spiritual beings having a human experience.
- We create our own reality.
- We are in the midst of a transformation.

- The Earth is a self-organizing living Being.
- The vibratory frequency of Earth is accelerating.
- The feminine principle is emergent.
- Science and spirituality are moving toward one another.
- Our consciousness is expanding to fourth dimensional reality (and higher).
- Consciousness is the "ground of all being."
- Consciousness survives death.
- Thought is a creative force.
- Focused, simultaneous thought by many people can change the world

THE HARMONIC CONVERGENCE

One of the clearest demonstrations of the effect that written words can have on consciousness is the electrifying event known as the Harmonic Convergence. José Argülles was in a hotel room in Los Angeles when he channeled the idea of a worldwide celebration to mark a major moment in time, as measured on the Mayan Calendar, that was soon to arrive. Within a brief time, serving as the initiator and the director of the event, Argüelles inspired far more than 144,000, his target number of people, to gather in ritual circles at dawn on August 16th and to gather again at sundown on August 17, 1987 for closure — exactly twenty-five years before the end of the Mayan Calendar in 2012. As a local participant in the Harmonic Convergence, I recognize that joining in such a huge experience had a lasting effect. The Convergence demonstrated the power in focused thought and left a large body of people with a sense of belonging to an earthly community. The event was the result of expert communication skills.

Crop circles are a highly visible means of communication. Isabelle's understanding is that individuals who are programmed by memory or inheritance will recognize certain symbols in the crops. She predicts

that by the year 2012, the end of the Mayan Calendar, science will be affected by the wisdom encoded in the agriglyphs. One of her channeled messages is "The scientists and the mystics are going to have to get together. All ability, be it of heart or mind, comes from the same source."

From my reading in the years since I met Isabelle, I have come to believe that scientists and mystics are already coming together. Many theoretical physicists express ideas that are as mystical as those of the channelers. Using different methods of acquiring knowledge, these separate groups are describing a similarly holistic, multidimensional universe characterized by conscious energy.

In certain states of awareness, we encounter other dimensions. Our mental energy patterns, detectable through an encephalogram, are powerful connectors to the entire background energy of the universe itself. Through our minds, we transmit electromagnetic energy and we receive it. *Crop circles can trigger our receive/transmit response.*

ALTERED STATES AND NONLOCALITY

As we traverse a day we experience different levels of awareness, or dimensions of consciousness, depending upon which state we are in at the time. We are equipped to deal with physical reality in a logical manner, and at the same time we can dream, remember, and imagine in ways that span time and space. Therefore, we experience a multidimensional world every day.

Our brain waves demonstrate variation in frequency according to the state of our consciousness. If we are up and about our affairs, our thinking brain emits Beta waves (above 14 Hz). When we relax, our brain also slows down to Alpha activity (between 8 and 14 Hz). As we move into dream states at the edge of sleep, in mystical moments, in states of bliss, creativity, Out of Body journeys, or altered states, our brain slows into Theta activity (4 to 5 Hz). While in deep sleep our brain waves subside to the Delta frequency (below 4 Hz).

Cynthia Sue Larson makes the point that we are composed of quantum wave/particles just like all forms of matter. We project an energy field beyond the limits of our bodies that merges into the background energy field from which all matter arises. Nothing separates us from All That Is. (*Magical Blend*, #68, "Reality Shifts.")

Our brains are under our control to a great extent. We empower ourselves through intention to affect the vast array of overlapping energy fields of which we are a part. Thoughts go on forever in a nonlocal universe. Nonlocal is a term taken from quantum physics which refers to the essential oneness of the totality, the All That Is. A nonlocal event is one that is not dependent upon time or space. *Crop circles are a nonlocal event.*

As lay people, we are coming to understand the concept of nonlocality as it affects our consciousness and the world around us through the efforts of those edge thinkers who are distributing these ideas via the symposia circuit and in their writings. I have selected some of those who have been the most instrumental to me in trying to understand the web of concepts that relate to crop circles:

EDGAR MITCHELL

Edgar Mitchell is one of the many harbingers of world change who can articulate and manifest a vision of the future. He was an astronaut and the eighth man to walk on the moon. On the return voyage he had a spiritual epiphany when he suddenly perceived the total connectedness of the universe.

"...as I looked beyond the earth itself to the magnificence of the larger scene, there was a startling recognition that the nature of the universe was not as I

had been taught. My understanding of the separate distinctness and the relative independence of movement of those cosmic bodies was shattered. There was an upwelling of fresh insight coupled with a feeling of ubiquitous harmony — a sense of interconnectedness with the celestial bodies surrounding our spacecraft." (Mitchell, 1996, p. 61)

Mitchell soon retired from the Navy and the astronaut program, and founded the Institute of Noetic Sciences whose purpose is to study consciousness. "I wanted to become intimate with the velvety blackness that I'd felt so connected with on the way home from the moon." (Mitchell, Ibid. p. 136)

In their announcement on the founding of IONS in 1978, the directors published this statement:

Civilization is in a critical state and mankind is at an evolutionary crossroads. On the one hand, problems and conflicts have arisen which are global in scale and have brought society to a condition of escalating planetary crisis. On the other hand, humankind's potentials for creative change, fulfillment, and benevolent control of our environment have never been greater. Both the problems and the potentials are ultimately a function of consciousness.

Mitchell says he moved from outer space to inner space, which he feels is the more important frontier. He has written that mind and matter are not "separate realms; rather they are two inseparable aspects of a single evolving reality." (Mitchell, Ibid. p. 137)

The unity of two opposites Mitchell defines as a dyad. Explaining his dyadic model, he speaks of the emptiness of space, which is actually filled with energy, as David Bohm theorized; it is the zero-point field which "...has been interpreted as that field of energy that underlies all matter. This is the basic, infinite unstructured quantum potential from which the Big Bang arose. Everything we know (and everything we don't) arose from the zero-point field of energy...we've discovered that matter is interconnected and 'resonates'

in some mysterious manner throughout the universe, and that patterns repeat themselves as though a template were being used over and over again on different scale sizes." (Ibid. 138)

In a talk given in Albuquerque, he said, "Perceiving energy from the inside is being conscious... In the last five or ten years, science has been taking the study of consciousness seriously. In physics, consciousness has a role in evolution. We now seem to be in agreement that we live in an intelligent, self-organizing universe. Knowingness has evolved along with beingness." He describes cosmic consciousness as a "state in which there is constant awareness of unity with the universe pervading all aspects of one's life." In his autobiographical testimonial, Mitchell mentioned the connected thrust of new science in these words, "To simultaneously reveal the nature of mind and the mind of nature is a single, interconnected, interactive process." (Ibid. p. 138) A quality of mind, scientific by training but open to mystical experience, marks Mitchell. To me, Edgar Mitchell is a "hero of synthesis."

As he concludes his book, Mitchell becomes ever more philosophical. He believes the human race is evolving towards a god state. He says that we first imagine, and then we create our own future. "The gods we have imagined are the forerunners of our abilities...We will evolve into galactic explorers in order to know ourselves." He should know. He already is one.

WILLIS HARMAN

Willis Harman spent the last twenty years of his life serving as president of the Institute of Noetic Sciences. He guided the organization through its phenomenal growth. Harman was an unpretentious Renaissance man. His breadth of vision was matched by his clarity of expression in such books as *Higher Creativity* and *Global Mind Change*. His wisdom continues to

influence me. I often reread what he wrote and listen to his tapes.

The assumptions on which science is based have changed over time. For Harman, these assumptions form a Metaphysic. Harman defined the new paradigm shift that science is presently undergoing as M-3, or Transcendental Monism, in which mind or consciousness is primary. Mind comes first. Matter follows. We are leaving behind the concept that mind arises from matter. The new metaphysic is an update of the ancient esoteric spiritual traditions of the Kabbalah, Eastern philosophies such as the Tao, tribal beliefs, and mysticism. With M-3, we can include those avenues of speculation now considered to be anomalies and thus outside the box of science. Harman did not argue that M-3 is true, but he found it more "congenial" to the totality of human experience than the limits of the scientific method. M-3 expands the scope of objectivity, causality, positivism, and reductionism. "Think how revolutionary a thought this is," Harman asks, "that science should now accommodate consciousness as a causal reality." (Harman, 1998, p. 9)

He writes, "The out-of-consciousness, collective/universal mind is creator of the world that conscious individual mind experiences." (Ibid. p. 34)

Science has not yet accepted the new paradigm that Harman posited. What makes this time exciting to witness is the progress of the more holistic way of thinking as it wins acceptance, one person at a time. The new paradigm is expansive, inclusive, and transpersonal. Since it is based on consciousness, the new metaphysic prepares the way for exploring the continuation of consciousness, such as Mark Macy is studying in Boulder. Harman supported such studies. He extended his notion of mind to the transpersonal experience, especially of death. He said, "We don't go somewhere at death; we are already there. In general, the center of awareness shifts at death from the physical to higher planes." (Ibid. p. 86)

The basis of Harman's thoughts was his breadth of knowledge. He was a frequent traveler along the forward edge of thought in the sciences. He amalgamated the scientific process with a holistic perspective in which all other aspects of our knowledge had a place. In his fruitful life, Harman wrote about how the new paradigm will affect business practices, biology, medicine, and further explorations of consciousness.

As physics and other sciences develop, leading voices are suggesting metaphysical dimensions to reality that are based on the concept that the background stratum of everything is conscious energy. I believe we are being coerced into contemplating the meaning of this changed picture of reality.

From our subjective perspective within evolution, we assume that as humans we are the pinnacle of the process. Our bodies seem to have stabilized in their present form. Our consciousness, however, is still evolving. In recent years we have witnessed the power of our consciousness when mobilized toward a concerted end. With each achievement, human beings reach a more elevated state of awareness, but I doubt that we are at the apex toward which evolution has been moving. At the present time, we are still struggling to reclaim a level of awareness probably achieved in the past more than once. A sense of deja vu pervades our strides toward multidimensional consciousness. As one enormous development in our genetic and mechanical technologies follows another in compacted time spans, something whispers, "Hasn't this all happened before?"

RUSSELL TARG AND JANE KATRA

While in altered states, we are capable of what Russell Targ and Jane Katra, Ph.D. call *Miracles of Mind* in their book of that title. The first sentence is, "This book is about connecting to the universe and to each other through the use of our psychic abilities." Targ is a

physicist who pioneered in the development of advanced laser remote sensing systems. He is a co-founder of the Stanford Research Institute remote-viewing program. Targ has twenty years of experience in training ordinary people and also gifted psychics to cast their minds into that void where space/time can be leapt in order to see a designated target — such as a secret nuclear base in Russia during the Cold War. Drawings of what one viewer saw at that target were checked later against satellite photographs which confirmed their accuracy.

Katra has a doctorate in health science. Through experience Katra has learned that effective remote healing is enhanced by transmitting a specific message to strengthen the immune system of the ailing person rather than by sending more diffuse prayers for healing. She has found that the immune system responds best when it is directly encouraged to inaugurate its own healing.

The effects of remote healing and remote viewing are created when the practitioner is in an altered state of consciousness, or we could say "in a different dimension of consciousness." Targ and Katra believe everyone is capable of remote viewing and remote healing. Remote viewers and healers make contact with nonlocal consciousness. The first step is to quiet the mind. Secondly, one must visualize the desired result. It is important to stay in the altered state and not to drop back into either analytical or imaginative thinking. The task is done by allowing one's inner eye to focus on whatever image is received and to trust it. Targ and Katra's subtitle is *Exploring Nonlocal Consciousness and Spiritual Healing*. "It's this mysterious nonlocality that brings new insight into a number of problems, including those of many enigmatic, subjective attributes of consciousness," writes Edgar Mitchell. (Mitchell, 1996, p. 114)

DAVID BOHM

Targ cites David Bohm's theory of wholeness. Bohm's model of the universe is a hologram in which each part reflects the whole. In Bohm's theory, the totality of the universe is a plenum, a sea of energy. There is neither space nor time in the plenum. Accessing it allows the remote viewer freedom to reach any destination.

The plenum is synonymous with the zero-point field. Edgar Mitchell makes this interesting comment, "The zero-point field has no characteristics other than energy, but energy with the seeds of learning, awareness and intentionality." (Mitchell, 1996, p. 169) The vast zero-point energy field is undetectable until excited. One way to create an effect in the field is with thought. In the model that Bohm has suggested, the ripple of thought moves across the plenum and gathers itself into matter.

The remote viewer and remote healer contact this nonlocal plenum and excite it through the power of their focused intent to produce an effect. Since focused thought produced in altered states has been proven effective in remote healing and viewing, we might safely assume that it could be used to create other effects, such as a crop formation.

David Bohm gives the name "holomovement" to the undivided multidimensional totality of All That Is, which is indefinable and immeasurable. He says that the vast sea of energy in space includes the principal of life and inanimate matter. "Clearly, a molecule of carbon dioxide that crosses a cell boundary into a leaf does not suddenly 'come alive' nor does a molecule of oxygen suddenly 'die' when it is released to the atmosphere. Rather, life itself has to be regarded as belonging in some sense to a totality, including plant and environment." (Bohm, 1980)

The holographic model Bohm has projected is a familiar contemporary optical image. As an illustration of the ancient belief in Oneness, it is beguiling. It

transcends scale. Each tiny part of a hologram reflects the whole. Our cells are holograms reflecting our bodies. Our bodies and our minds are holograms that reflect the totality of which we are a part. To know the universe we can begin with ourselves. What we find in our own awareness is a clue to the consciousness of the universe. And, vice versa, if we discover an attribute of the universe at large scale, we can be assured by this model that we also contain that attribute.

Bohm uses the term implicate order to describe the plenum where all potentials are enfolded in the zero-point field. Waves of excitation to the field unfold these potentials into the explicate order of matter that we perceive as reality. Everything that is held *in potentia* has an *a priori* existence in the implicate order as a possibility. Bohm posits that the plenum is conscious. Consciousness was present from the beginning — the Big Bang — and it is the matrix within which everything that exists is conscious. He writes, "...the implicate order applies both to matter (living and non-living) and to consciousness..." In other words, all parts of the holographic universe are connected through conscious energy. Bohm writes, "...the quantum theory has a fundamentally new kind of non-local relationship, which may be described as a non-causal connection of elements that are distant from each other..."

Bohm's inspired book, *Wholeness and the Implicate Order*, has greatly influenced my thinking. He explains his philosophy not only in mathematical terms but in vivid words. Bohm's holographic paradigm is familiar to artists who enter into a plenum of possibilities when they allow their creativity to carry them unfettered to the source of their imagery and content.

FRITJOF CAPRA

Fritjof Capra's *The Tao of Physics* was one of the first books dealing with physics that I read. Because it is a poetic as well as instructive book, it grabbed my attention and left me with a picture of the universe I otherwise would have lacked until years later. On two occasions, I traveled to hear Capra speak, once in San Diego and again in Santa Fe, New Mexico. From his lectures, I derived the concept that the universe itself is intentional. Capra told his audience about the think tank at Berkeley led by Geoffrey Chew whose shared subject was Bootstrap Physics. In San Diego, Capra drew a diagram on the blackboard to represent a photon entering the atmosphere where it collided with another photon and headed off in a particular direction rather than a random one. I asked him if physicists could now say that perhaps there is a possibility of an intention behind the direction a particle takes, with the assumption that the countless interactions of particles eventually lead to the reality we experience. He said that if all the qualifiers, the perhaps and the possible and the maybe were in place, the answer is yes. From that time on, in the late 1980s, I have believed that at the most elemental level the universe reflects an ability in matter to choose among potential paths.

Capra writes of the essential wholeness of the universe. In *The Turning Point* he says lucidly, "As we penetrate into matter, nature does not show us any isolated basic building blocks; but rather appears as a complicated web of relations between the various parts of a unified whole..." (Capra, 1983, p. 81)

And Capra discusses relationships in ecological systems, "Like individual organisms, ecosystems are self-organizing and self-regulating systems in which animals, plants, microorganisms, and inanimate substances are linked through a complex web of interdependencies involving the exchange of matter and energy in continual cycles." (Ibid.)

To the web, I would add humans and human thought as effective contributors to interdependencies. Gregory Bateson, one of Capra's heroes, was an advocate of Willis Harman's view that mind preceded man;

mind even preceded the development of the brain. In conversations that were determinants in Capra's thinking, Bateson, told him "...mind is a necessary and inevitable consequence of a certain complexity which begins long before organisms develop a brain and a higher nervous system." Bateson emphasized that mental characteristics were manifest in social systems and ecosystems and that "mind was immanent not only in the body but also in the pathways and messages outside the body." (Capra, 1988, p.83)

Within primordial consciousness there is an apparent capacity to determine the timing of events that unfold in our perceived world of matter. Evolution, a coalescence of matter into star systems and the dynamic, on-going expansion of life, is marked by momentous junctures and mutations. A subtle guidance underlies the majesty of the volatile universe.

PETER RUSSELL

Peter Russell addressing a Consciousness and Spirituality Conference in Albuquerque, 1999, said that "Everything we know is a manifestation of consciousness." His statements included these thoughts:
- We create our own reality.
- Our brains are creating our experience.
- We know only our brain's reconstruction, not the reality that is out there.
- Consciousness is the ground of all being, the fabric out of which our experience is woven.
- Consciousness creates itself.
- We can speed up our inner evolution by learning from each other.

Since the Harmonic Convergence of 1987, our mental connectedness has become more global. The AIDS crisis spread worldwide from its origins in Africa, destroying our sense that there are safety zones on Earth. The World Trade Center destruction has had global repercussions. We have learned once and for all that what happens on the planet anywhere affects all of us. Despite the surface enmities and retrograde tribal wars, recent attempts to create solutions and regulations for global warming, control of fishing, pollution, water and air purity, farming methods, and space exploration are bringing people closer together as they reach across boundaries and find ways to work together for the benefit of Earth. If we succeed in learning true cooperation for the good of the planet, it would be unique in recorded history, a singular achievement not made, as far as we know, by any prior human race. Had the former civilizations created global altruism, it is doubtful they would have disappeared.

Global consciousness is propelled by our huge strides in electronic technology from the telegraph and telephone to wireless communication, satellites, the Internet, fiber optics, computers, cameras, and space vehicles. The ability to publish images instantly regardless of distance has emphasized that we share this planet. We are both witnessing and advancing a major development in the evolution of human consciousness. Essentially, we have created electronic extensions of our physical and psychic senses.

ZECHARIA SITCHIN

We are not only creating a new, holistic paradigm to incorporate new discoveries and insights. We are also being given access to ancient wisdom that affects our sense of where we came from and where we might be going. Zecharia Sitchin writes authoritatively of how evolution on Earth has been manipulated from the beginning. He is the author of the *Earth Chronicles Series*, including *The Lost Realms*, *The Twelfth Planet*, and others. (Note that Sitchin's number 12 includes the sun and the moon.) The twelfth planet is Niburu which crosses into our part of the solar system only once

every 3,600 years Sitchin's expertise in translating ancient texts makes his work noteworthy. Although he is outside the mainstream of science, Sitchin's translations of ancient Sumerian writings are cited by Edgar Mitchell and others as valid sources of information. Written artifacts on clay tablets from the Sumerians tell the vivid history of the Anunnaki of Niburu and their interactions with Earth.

When their own planet was threatened, the Anunnaki decided they could preserve its atmosphere by injecting gold particles into their stratosphere. They came to Earth to explore for gold. The physical labor became too hard for the spacemen/miners who eventually revolted against their leaders. As a result, their medical director, Ninmah, experimented in her laboratory aboard their spacecraft to create hybrids from Anunnaki cells combined with those of primitive humanoids. These created beings were at first infertile serfs, but later the Niburuans reengineered them to be self-reproducing. The first man they made was stamped with their own likeness. He was known as The Adam, the man made from Earth. Adam's mate was also created in the laboratory.

Sumerian records are in Sitchin's estimation the original source upon which the Bible and other ancient texts were based. He maintains that the main story of human genesis is derived from a sequence of actual events. All ancient literature refers to "gods" who mated with the daughters of Earth. Aboriginal stories of Native Americans, Polynesians, and Africans, describe present-day humans as descendants of Star People. Sumerians recorded The Flood which is found worldwide in traditional lore.

Sitchin postulates that the origin of DNA was on the 12th planet, Niburu. Guided evolution led first to *homo erectus*. Niburuan science produced the first modern man who appears abruptly without any "missing link" 300,000 years ago. The Nefilim, as the visitors are named in the Bible, were on Earth before the Adam — the first *homo sapiens*, was created. "It is modern Man as we know him that the Nefilim created." (Sitchin, 1976, p. 341)

CHANNELING

Words are potent. Some people react negatively to the word 'channeling,' associating it with the New Age and dark forces. A channeler is a modern oracle, a respected person in ancient Greece but suspect in our time. The biblical word prophecy is largely acceptable due to respect for its source, even though the biblical prophet acted as a conduit for wisdom in the same way that contemporary channelers do, by receiving a complete message from an apparently exterior source. The everyday word 'breakthrough' carries less baggage and is used frequently to describe the moment when new knowledge arrives spontaneously, an event that is common to mystics, artists, and scientists.

Jon Klimo, in his *Channeling, Investigations on Receiving Information From Paranormal Sources*, writes: "Channeling is the communication of information to or through a physically embodied human being from a source that is said to exist on some other level or dimension of reality than the physical as we know it, and that is not from the normal mind (or self) of the channel." (Klimo, p. 2)

Channelers are gifted with an extraordinary capacity to reach beyond their usual form of thinking to an ineffable dimension. In order to receive messages, the channeler, knowingly or unknowingly is in an altered state of awareness during the transmission. A channeler can transmit a message that requires an answer. Therefore, channeling is a form of signal and response. It is a valid and widely experienced source of information even for those who profess not to believe in it. All creative thought is a form of channeling which occurs when information penetrates human consciousness from a more conscious source.

An occasion in which Einstein may have channeled information is described in this anecdote told by Kip S. Thorne in *Black Holes and Time Warps, Einstein's Outrageous Legacy*: "As happens to most people immersed in a puzzle, even when Einstein wasn't thinking directly about this problem (gravity), the back of his mind mulled it over.

"...one day in November, 1907, in Einstein's own words, 'I was sitting in a chair in the patent office at Bern, when all of a sudden a thought occurred to me: 'If a person falls freely, he will not feel his own weight.'" (Thorne, pp. 96-97)

Willis Harman and Howard Reingold, in a section titled "The Breakthrough Phenomenon," from their book *Higher Creativity, Liberating the Unconscious for Breakthrough Insights*, write, "...in the case histories of scientists, we found that not only many specific scientific discoveries but the very foundations of science itself were built on breakthrough experiences, later backed up by empirical investigation. It is ironic that science, the institution that has most strongly branded these kinds of experiences as daydreams, delusions, or hallucinations, appears to have been born in just such a state — in a fever dream, in a flash to an individual who could not solve the problem with the conscious portion of the mind." (Harman & Reingold, p. 5)

Creativity, resulting from breakthroughs, depends upon first stocking the mind with pertinent material, doing one's homework in deep thought and study, then waiting, going off-line in modern lingo, in a state of trust. The breakthrough occurs when the mind is turned away. The process is no different for the medium, the oracle, the shaman, the artist, or the scientist. Blinding flashes of intuition come into a prepared mind. Isabelle Kingston prepares herself through prayer.

In recent years, two major sources of channeled information are often cited, even by scientifically oriented authors. These are *A Course in Miracles*, channeled by Helen Cohn Schucman, who worked in the Psychiatry Department of Columbia University, and the Seth material channeled in a series of books by the poet and novelist Jane Roberts. Schucman channeled a form of wisdom devoted to how we can experience miracles by taking charge of our lives, attuning ourselves to the universe in a state of trust, and by rendering ourselves harmless. Willis Harman openly praised the course as influential in his thinking.

Jane Roberts had no special knowledge of physics, but Seth, who seemed to be a distinctly separate person, described the multidimensional structure of the universe, giving a picture of the relationships among consciousness, matter, and a basic energy sublayer which is very close to the paradigm projected by theoretical physicists. Roberts, in her own personality, had a vividly active multidimensional awareness. She habitually scanned her inner horizon and she was able to go into a receptive state of consciousness by focusing her mind, and then to surrender it to Seth and other discarnate personalities, such as Paul Cezanne and William James. The wisdom books she channeled were an early opening of consciousness for me and thousands of others. Seth altered my view of reality. From "his" words, I gained an understanding of the interactive nature of the universe. I bought and read almost everything Roberts channeled. I still find some of her books of unique value, especially her two volume work, *The Unknown Reality* and the imaginative novel *The Education of Oversoul Seven*. Her channeled book about Paul Cezanne's thoughts after his death is one of the most insightful books on the artist's process that I know.

Seth projects such a noble and enlightened nature, he stands out among the many channeled entities. He states clearly that he does not know all the answers to eternal questions, but he does describe a complex, multidimensional universe of universes. Seth begins

with the structure of the human personality, which he says is composed of an outer ego within the three-dimensional world and an inner ego connected with higher dimensions. Seth proposes that there are many universes adjacent to one another or occupying the same space, in which counterparts of each of us are following their lives just as we are, and there is an interactive, mutual effect from one aspect of an oversoul to another. The decisions we make affect our counterparts; our decisions are dependent upon theirs. There are more *I's* in one of us than we know.

The basic building blocks of the Seth universe are CUs, units of consciousness which are not physical. They are in all places at all times simultaneously. They are precognitive and clairvoyant, conscious, aware, and unpredictable, which allows for infinite patterns and fulfillments. We all are possessed of CUs, and it is our thoughts and emotions that form into physical matter. "In a sense, the CUs are divine fragments of All That Is." (Friedman, 1990, p. 123)

Norman Friedman isolates aspects of Seth's philosophy that to my mind are links with crop circles. CUs can take on form and become separate entities, or they can flow together in a vast harmonious wave of activity as a force. "Before matter appears, there is a 'disturbance' in the spot of space-time where the materialization takes place." This disturbance slows down faster-than-light CUs and freezes them into form. Friedman compares Seth's model with quantum physics philosopher David Bohm's belief that matter is made up of conscious connected light rays that have frozen into a pattern.

Seth says that matter is solid only in our three-dimensional world, not in the worlds that are adjacent to ours. But, he also says that there are specific "coordinate points" where energy flows between worlds. "...coordinate points represent accumulations of pure energy." (Ibid. p. 127) Seth promotes the idea that our thoughts activate these points, and our thoughts gain energy through them. "The intersections of thought and coordinate point make possible the projection of thought into physical matter," depending on the intensity of the thought. (Ibid. p. 127)

In addition to CUs, Seth speaks of EE units, units of electromagnetic energy which are "natural emanations from consciousness." EEs can pulsate and change form. Emotions can enhance the power of EEs. "The EE units are not confined to human consciousness but arise from all levels of consciousness, including the cellular." (Ibid. p. 130)

Seth's explicit structure that systematically links consciousness with the creation of matter offers us a possible vehicle for the creation of a crop circle. Sages among us who have gained control over the CU/EE connection may be working with it to create crop circles or other phenomena at will. Or, prodigies might be creating such effects without conscious awareness of their mental powers.

Norman Friedman has synthesized the Seth material expertly; he compares it with both physics and the perennial philosophy. One of the Seth ideas that expands the crop circle issue is this statement from Friedman: "An anomaly may not be explainable to the outer ego within its system of information. But with a wider focus, the anomaly can be understood." (Friedman, 1990, p. 118). My effort is to widen the focus as we contemplate the crop circle phenomenon.

CIRCLES ON THE EARTH

*"There is little doubt...that the patterns in the corn
have a meaning, and the meaning of such things
is to be found in the way people are affected by them."*
—John Michell

Crop circles remind me of a childhood adventure with my mother on an early dawn when she planted in my imagination a sense of wonders that happen out of sight. "The fairies have been dancing here," she said, pointing to the dewy lawn where the grass was splayed back to make small circles. The sense of potential magic she gave me that day returned when I saw crop circles for the first time. As often happens when you are fascinated by a subject, it becomes a part of your life.

Martha Grimes summed it up in her mystery *Hotel Paradise*, "Certain problems just attract us. They're attractors, they're like magnets. And once drawn to them, you can't quite stay away." Crop circles are like magnets to me.

PLACES OF POWER AND THE INVISIBLE UNIVERSE

Paul Devereux gives an account of The Dragon Project in his book *Places of Power*. With little funding, a group of people dedicated themselves to measuring the energies transmitted at sacred sites in England and elsewhere. They targeted these anomalies: the background radio activity — caused by the displacement of oxygen with radon gas, light phenomena, such as lightballs that

rise in the air and can be over a foot across; magnetism of megalithic stones; and "the effect of selected sites possessing geophysical anomalies on the dreaming mind."

In far earlier times, Devereux says people had a deeper understanding of the spirit of place, but it began to lessen between 8000 and 5000 years ago when agriculture arose. "The intimate knowledge these ancient people had of the nature and usage of their materials still conjures awe in the modern visitor to the ruins of England's Stonehenge, Ireland's Newgrange, America's Serpent Mound, Peru's Machu Picchu, Egypt's Great Pyramid..." (Devereux, 1999 edition, p. 12)

Devereux cites John Michell who showed that English mounds were built by alternately layering organic and inorganic material, a method akin to the one used by the controversial twentieth-century inventor, William Reich, who built his Orgone Box to "accumulate energy." Serge King, in his classes on Polynesian Huna philosophy, taught a technique to create a similar energizer. By placing a sheet of plastic wrap over a sheet of aluminum foil and crushing them together it is possible to make an energy enhancer akin to an orgone box. King recommends putting some of the little balls under the bed to increase energy during sleep.

The Dragon Project found noises coming from the Rollright Stones in Oxfordshire, electromagnetic transmissions from Cornish standing stones, and a point where the compass reversed because it was adjacent to stones at Carn Ingli which "retained the direction of the earth's field when they were formed." (Ibid. p. 126) The team members sensed that early builders were geomancers who were aware of the energies in the stones they chose and also in the sites where they placed them. The researchers discovered higher than background magnetic readings around stones with crystal content. Essentially, The Dragon Project grounds the power of sacred sites in measurable ways and pays homage to the wisdom of Neolithic builders who seemed to be attuned to these attributes.

SACRED SITES

Certain places on the Earth seem to be transfer points in which a concentration of spiritual energy, or information, is gathered. We have come, especially recently, to call these special places *sacred sites.*

Rina Swentzell, a Santa Clara Indian of New Mexico, spoke to Devereux about a shrine at her pueblo, saying that shrines were "points where the possibility for contact with different levels of existence happen." (Ibid. p. 13)

Crop formations frequently appear in alignment with sacred sites. Isabelle's emphasis on that connection is one of her major contributions to crop circle research. She says, "Crop formations occur near ancient sites around the world. You see it in Australia where the circles appear near Aboriginal sacred sites and in the United States near Native American sites. In addition to the symbolism appearing in the fields of England the same symbols are found in New Mexico, Arizona, and elsewhere in permanent form as petroglyphs..."

Crop formations in England are only one aspect of a mystical dimension that has long been felt in the British Isles. Isabelle has channeled that there is an energy field, pyramidal in shape, surrounding and soaring above England. Within this invisible field, ancient information has been stored as energy, much the way we now store data on a disk. Mystics from around the globe are making pilgrimages to the sacred places in England, especially those in Wessex. They believe their visits are instrumental in releasing the information stored there by re-energizing the sites. Rupert Sheldrake warns that while pilgrims enhance the energy, tourists drain it. He recommends that tourists become pilgrims. (Sheldrake, 1991) *The energies implanted in Avebury, Silbury Hill, and Stonehenge might be coded to reopen, and crop circles that cluster near sacred sites may be the signal that triggers these energies to awaken.*

THE WESSEX TRIANGLE OF SOUTHERN ENGLAND

Isabelle explains that the Wessex Triangle has been used spiritually by people for over 5000 years. "It's where you'll find the ancient sites of Stonehenge, Avebury, and Silbury Hill, and many standing stones, and other sacred places. They haven't been built over (in modern times) so the Earth energy is still there, unspoiled but dormant. Ancient Wessex was the seat of the old kings when Winchester was the capital of England. It is pre-Celt, pre-Druid, from a time when many ancient civilizations understood the great connection between the universe and the Earth."

Most crop circles are found in this 360-square-mile area that links Wiltshire and Hampshire in Southern England. The gentle landscape is known for its downs — low chalk hills covered with hundreds of acres of fields that have been under cultivation for centuries. From the air, the scene is like looking at Robert Louis Stevenson's *Counterpane*, a quilt of golds and greens.

Southern England is a limited area, easily monitored by air. Crop circles are quickly discovered there and reported by pilots of small planes. (The news is then shared through a telephone tree that includes Isabelle Kingston.) Grassy local airfields are plentiful and there are sufficient pilots of small aircraft to service the needs of photographers. Members who join the Crop Circle Connector or viewers of other crop circle websites have access to an archive of clear, aerial photographs documenting the development of crop formations in England and other countries around the globe. The last two decades of the twentieth century marked the abundant appearance of crop circles in all grain-producing nations. Because it is such a confined area, the record of crop circles is densest for England.

When Isabelle is asked, "What's so special about England?" she answers, "If you're going to paint a picture, you have to have a good canvas. We certainly have the right materials in England."

LEY LINES

A palpable presence of "otherness" pervades the Wessex countryside. The land is crisscrossed by ley lines, which are subtle energy currents within the earth that a dowser can detect. The founders originally laid out a town and set the roads on these ley lines; or as Huna master Serge Kahili King says, we create such energy lines by repeatedly traveling over them. Animals intuitively follow ley lines; observers have seen cattle or sheep walking behind one another in single file along tracks that, when dowsed, are found to be energized.

Sacred sites are situated on ley lines, confirming that Neolithic people sensed forces within the earth. They personified energies found in nature as gods and goddesses and built great stone temples in their honor on ley lines. Christians built their churches over the very same places already recognized as hallowed by earlier people. The St. Michael Ley Line, which carries masculine energy, was dowsed and mapped by Hamish Miller and Paul Broadhurst. (Miller and Broadhurst, 1989) From St. Michael's Mount off the southwestern Cornwall coast to Norfolk on the English Channel, over 500 churches, barrows, tumuli, wells, and chapels are dedicated to Michael. The St. Mary Line carries feminine energy as it weaves across a similar path as the Michael Line. Along its length, numerous sites are devoted to Mary.

One point where the Michael and Mary lines cross is in the living room of Isabelle's house. She says, "This great Michael line of power — which moves across England, off to Russia and around the other side, and I feel it crosses back through America, but we have not checked that out yet — actually sends out signals of what is happening within the earth. In pre-Christian times, the priests would walk this line from one site to another at particular times for ceremonies and initiations. Where they walked and connected their consciousness with the earth, they left energy. We call it vibes and we can sense them. The ancient sites retain these vibes."

Ley lines carry serpent or dragon energy. The serpent is a symbol for and an attribute of the Goddess of Wisdom in her several guises, such as Sophia, Astarte, etc. Many early people worshipped the serpent as a protector and source of life. In China, serpent energy is honored in carvings and paintings as the nourishing, feminine life force or *chi*. Aboriginal people of the Southwestern United States and Mexico revere a winged serpent or dragon that symbolizes water and Earth wisdom, the feminine aspect of God. The Judeo-Christian story of The Expulsion of Adam and Eve, on the other hand, promotes hatred of the serpent. (Plate 9, p. 39)

James Swan links our physical bodies with the serpent force, "All around the world, the images of the serpent, the snake, and the dragon symbolize the Earth

force, as well as the first chakra at the base of the spine, which is said to contain 'kundalini' or 'coiled serpent' energy." (Swan, 1990, p. 148)

MYTH

Joseph Campbell told us that the old myths do not encompass what we have discovered as we have expanded our sense of distance, size, and depths of time. He spoke of "prayers still being addressed in all seriousness to a named and defined masculine personality inhabiting a local piece of sky a short flight beyond the moon." (Campbell, 1985, p.43) Classic myths are restricted by the limits of knowledge available to those who conceived them. We have no myth that addresses "the inconceivable magnitude of this galaxy of stars, of which our life-giving sun is a peripheral member, circling with its satellites in this single galaxy among millions within a space of incredible distances, having no fixed form or end." (Ibid. p.43) Our responsibility is to create myth that accounts for the far reaches of outer space and the inner reaches of microspace. This myth for our time may emerge from our feeling of responsibility for the planet and our guilt, which reflects the shadow side of our highly materialistic culture.

Christian de Quincey has amplified the loss of myth in his article "Stories Matter, Matter Stories":

> If we are to feel at home in the cosmos, to be open to the full inflowing and outpouring of its profound creativity, if we are not to feel isolated and alienated from the full symphony of cosmic matter...we need a new cosmology story. (*Institute of Noetic Sciences Review*, June-August, 2002, p. 10)

A mythic language is emerging in the discussions of crop circles. The term Circlemakers, for example, implies a source comparable to the gods of yore. Quite likely one meaning of the crop circle phenomenon

relates to our felt need to heal the Earth, personified as the goddess Gaia. Sensitive people interpret a number of crop formations as having the form of a goddess.

THE WATCHERS

Around 1982, Isabelle was told by her guides to move to the Wessex area where she had been raised. The source of the message was not her usual guides whom she hears while she is in an altered state of consciousness. She was fully awake when a new energy spoke to her. Isabelle said, "They told me I would be involved in something exciting and it would take me around the world. I was a garden variety medium before that, limited to (seeing) those not around in physical form or channeling my spirit guides and teachers, but this contact was not the same. They called themselves The Watchers. I had not heard of them, but to many others, they were familiar."

The Watchers appeared to her as huge angelic forms. Similar figures were reported by Russian cosmonauts who saw them flying beside their space craft. I will discuss these entities further in subsequent pages.

ISABELLE KINGSTON AND THE MERLIN FACTOR

Merlin, known in legend as the seer who taught and protected King Arthur, is also connected with Earth or dragon wisdom. Isabelle Kingston's home is on the outskirts of Marlborough. The name means Merlin's Barrow and the town motto is "the place where old Merlin's bones are buried." At first, in the legends of Merlin, he dwelled in an underground barrow where he was in close proximity and in communication with the Earth Goddess. Merlin derived his power of prophecy, according to these varied stories, from a red dragon and a white dragon. Merlin was a shaman. Certain crop

formations seem to contain his energy. Isabelle believes the Merlin crop circles are the ones with forks in them, designs thought to have both mathematical and musical significance.

Isabelle's guides told her, "You realize you are working with the Merlin magic." When she does her psychic readings she actually sees Merlin nearby. His persona clarifies her work. It is not surprising that she felt she was being assisted when she found her present home near Marlborough.

SILBURY HILL

Isabelle relates, "When I moved to Wiltshire in 1984 The Watchers told me to concentrate, with my spiritual group, on sending light and healing to Silbury Hill because it was by this mound that we would be given a sign. The hill had to be prepared for the energy to come in. So, for four years we zapped it with light. Every time we drove by we sent loving thoughts."

Once she had moved to the area, Isabelle waited without any reassurance that she had done the right thing by obeying her inner guidance. After four years, she finally heard there was a major occurrence below Silbury Hill. In her lecture she told us:

"Here is the story. Beginning in July, 1988, we were advised we would soon get our sign of intervention. My friend saw a big orange ball of light which came and accompanied her car as she drove. It was not a craft. Instruments in the car went crazy. They vibrated. The ball of light stopped over Silbury Hill and disappeared. When I heard that, I thought, 'She had MY sign.' But the sign was not that morning. It was the next one. Beside Silbury Hill was a crop circle. I had never heard of a crop circle. This was right by the main road going west. Everyone could see it. It hit the press. The crop circle was in the form of a Celtic Cross, with a large inner circle and four other smaller ones forming the cross around it. They came again eleven days later. By then there were thirteen circles in one field."

Isabelle channeled that the quintuplet formation signifies a connection to the four elements — air, earth, fire and water. She makes a point now of studying the satellite, or extra circles known as *grapeshot* that sometimes seem to be flicked across a field as if from a loaded paintbrush. She has dowsed them and found each of them has its own energy pattern. In her early days as a crop circle researcher, her guides told her to log these small circles on the computer. "They are connected with star systems and constellations, and there is a code in them. At some stage, we were told the grapeshot would be analyzed and understood by humanity." The fields near Silbury Hill continue to attract formations.

The day the quintuplet circles appeared at Silbury Hill, Isabelle heard a high pitched sound coming from the field and, at last, she saw again moving over the crop circles "fairy lights" she had often seen in childhood, when the neighbors called her the "fairy child." She associates these lights with devas or spirits of the plant kingdom. Crop circles unlocked a reservoir in Isabelle's memories. They provoked her intellectual curiosity and gave her a sense of intuition about the circles. She began to participate in the research group headed by Colin Andrews.

While waiting for some sign to confirm The Watcher's guidance, Isabelle studied archaeology at the University of Bristol. Silbury Hill, the largest manmade mound in Europe, is four miles from her home near a spring in a field that has been cultivated for centuries. The mound was built nearly 5000 years ago. In 1969, a probe by Bristol's archaeology department revealed that a small, inner chalk hill was covered in a kaleidoscopic pattern of colored soil, and then grassed over. The grass was still green when the site was opened and it was filled with the bodies of winged ants, a clue that it had been covered around the feast of Lammas on the

first of August, the only time such ants have wings. Enclosing this small grassy hill there is another structure, a six-step pyramid formed of stone blocks, resembling a spider web or chambered nautilus. Today, the entire hill is grass-covered. The hill protrudes from the landscape, exuding female connotations. Its shape is compared to a female breast or the womb of a pregnant woman.

Silbury Hill means The Hill of the Shining Beings, who might have been the Giants (Titans, Nephilim, or Elohim) referred to in the Bible, or a manifestation of The Watchers. The tall beings are the legendary helpers who guided the building of the mound. Isabelle refers to the tall ones as the Long Heads. She says the mound is a battery that brings energy into the Earth and transmits energy as well. Dean Comwell, another lecturer on the subject, describes it as a platform to join Earth and Sky. The mound was dedicated as a Temple to the Moon.

Silbury Hill is a component of the Avebury spiritual complex, the largest circle of standing stones in England. "The idea of standing stones is to hold the energies, to amplify them. Each one of the standing stones has a special feel, special meaning, and a special purpose," Isabelle explains. "Ancient man built this with axe blades and baskets. Around the outside, these high banks that go around the circle were to keep the energies in."

The same month, July 1969, that the Bristol archaeologists reached the absolute center of Silbury Hill, without finding a hoped-for burial site, Neil Armstrong landed on the moon. Isabelle finds that connection fraught with meaning. Magical thinking is based on such correspondences. The probe of Silbury Hill and the landing on the moon can be in relationship when one's thinking is altered from our world of three-dimensions to a more holistic perspective.

GAIA

James Lovelock, an atmospheric chemist, developed the Gaia Theory. "The Gaia hypothesis in its most general form states that the temperature and composition of the Earth's atmosphere are actively regulated by the sum of life on the planet — the biota...that life interacts with and eventually becomes its own environment; that the atmosphere is an extension of the biosphere in nearly the same sense that the human mind is an extension of DNA, that life interacts with and controls physical attributes of the Earth on a global scale — all these things resonate strongly with the ancient magico-religious sentiment that all is one. On a more practical plane, Gaia holds important implications not only for understanding life's past but for engineering its future." (Margulis and Sagan, 1997, pp. 145-146)

Lovelock developed his theory based on his observations of the volatile gases in Earth's atmosphere: nitrogen, breathable oxygen, hydrogen, and methane. Logically, these gases should have interacted, leaving the Earth cold, "engulfed in carbon dioxide, and lacking in breathable oxygen." He searched for the reason that the atmosphere remains life-supporting.

"In the Gaian theory of the atmosphere, life continually synthesizes and removes the gases necessary for its own survival. Life controls the composition of the reactive atmospheric gases." (Margulis and Sagan, 1997, p.152) Through photosynthesis, bacteria, algae, and plants continuously remove carbon dioxide from the air. Eventually, it becomes part of limestone reefs and animal shells. Microbes are "at the very center of the Gaian phenomenon." Humans are far less important and a far more recent player than microbes in this dynamic process.

"...human beings have only recently been integrated into the global biological scene. Our relationship with Gaia is still superficial. On the other hand, our ultimate potential as a nervous early warning system for Gaia remains unsurpassed...." (Margulis and Sagan, 1997, p.157)

Lovelock's theory is named after the fertile Greek Earth Goddess. The Gaia Theory entered the mainstream media about the same time as the feminist movement began promoting studies of the Goddess and calling for a reevaluation of the patriarchy. In an on-going discussion among psychologists, politicians, academics, and educators, the concept that Earth itself is akin to a female organism, a generator of life, is affecting consciousness at a basic level.

MIGUEL ANGEL RUIZ, TOLTEC NAGUAL

The Gaia Theory shares in its more mythical aspects a basic model of the universe with the Toltec tradition. Miguel Angel Ruiz, a former medical doctor and surgeon, is a Toltec nagual, a Master of Intent. He was one of the wise people I wrote about in *Artists of the Spirit*. At his request, I then wrote *Beyond Fear*, a book of the Toltec wisdom he teaches.

Tenets of the Toltec are:
- Earth is a Living Being.
- Humans in our totality are Earth's neural network.
- Rivers and oceans are the bloodstream of the planet.
- The atmosphere is Earth's lungs.
- The sun is also alive.
- Each planet is an organ of the sun.
- The universe is one living being.
- The present race is beginning the sixth cycle of human evolution.

The Toltec system of living beings is progressive. Up and down the scale every entity is a living being, composed of other living beings. These ancient concepts are akin to the Gaia Theory and to the ideas of contemporary physicists who tell us that the universe is a dynamic whole. Where there is life, there is also consciousness. In Native traditions and in new physics, consciousness is present throughout the universe. *Crop circles are related to the consciousness of the Earth itself.*

10. Lydia Ruyle *DNA* Handmade paper
Alton Priors, Wiltshire, 1996

59

RUPERT SHELDRAKE

Rupert Sheldrake is an English biochemist. In his book *The New Science of Life: The Hypothesis of Formative Causation*, published in 1981, Sheldrake outlined his theory that reality is organized through energy patterns that he calls "morphic resonance." From crystals to galaxies all organized entities have form. All forms can be described as morphs. All entities that have the same morph share a morphogenetic field. Sheldrake posits that all members of a field resonate to the same vibration; or one could say that they respond to the same information. He writes, "The holistic theory in effect treats all nature as alive...From this point of view, even crystals, molecules, and atoms are organisms...They are not made up of inert atoms of matter...Rather, as modern physics itself has shown, they are structures of activity, patterns of energetic activity within fields." (Sheldrake, 1991)

Sheldrake, writing for *The Quest*, August, 2003, p. 131, in an article titled, "The Extended Mind," made a statement that I believe links to the subject of crop circles:

> My idea of the existence of the mind beyond the physical brain is what I call the extended mind. I would like to suggest that the mind is much more extensive than the brain and stretches out through fields that I call *morphs*. Morphic fields, like the known fields of physics such as gravitational fields, are non-material regions of influence extending in space and continuing in time. They are localized within and around the systems they organize.

The transfer of information between members of a field requires no substance to "carry" the message. It does not rely upon time, nor does it involve space. Data transfer is instantaneous. We can say it is non-material and nonlocal. Morphic resonance holds memory. Once a pattern of behavior is created, memory of it is retained by all members of the field, and all *future* members of the field will retain the habit, regardless of where they may be.

Habit is a key word in morphogenetic theory. Sheldrake believes that evolution progresses through the cultivation of habits that are absorbed by successive generations in widening morphogenetic fields, especially if the habits are beneficial. He illustrates his thesis with a hypothesized initial creation of a synthetic crystal. Creating the first crystal is difficult, but a "habit" develops so that formation of the crystals becomes easier in the original laboratory, and this fluency soon is found in other labs wherever else the crystal is grown.

Sheldrake's ideas are based in a spiritually inspired understanding of how things work. The spiritual underpinning of his theory becomes evident when he addresses the apparently intelligent guidance of the evolutionary process in the universe. Evolutionary creativity, he says, "involves the coming into being of new kinds of morphic fields, where do these morphic fields come from?" (Sheldrake, 1991, p. 194)

He presents three possibilities, here digested from *The Rebirth of Nature*;

1. Creativity emerges from the mother principle in nature, unconsciously and spontaneously,
2. Creativity descends into the world of time and space from a higher level that is mindlike and it is guided by the father principle.
3. All creativity comes from the interplay between the mother and father principles, simultaneously from above and below, dependent upon chance and necessity. Sheldrake makes it clear that he believes the third choice is vital. Creativity depends upon both the masculine and feminine aspects of nature.

MORPHIC RESONANCE IN THE CROPS

With Sheldrake's morphic resonance in mind, I see the farm fields where crop circles appear as a

morphogenetic system of fields within fields. The farm field holding the crop is morphogenetic in itself. All the plants of wheat share the same morphic field. The cells within each plant resonate with the cells of all plants in the surrounding crop, but also they resonate with their counterparts in all other plants of the same type. The whole site is filled with distinct fields nested within fields, each representing a higher level of organization, and the site is connected nonlocally with all others that are similar.

The landscape of hills, trees, and ancient sites in which the crop formation appears constitutes a morphogenetic field that holds memory year after year. Its gradual modifications are enfolded within its morph. To enter the landscape is to encounter "the presence of the past." This phrase is the title of Sheldrake's second major book on his theory. Some visitors can sense the aura of shared history in a site. Sheldrake states that the morphic field of one sacred place has resonance with that of other sacred sites. "What happened in the past can in some sense become present there again, and thus they act as doorways to realms of experience that transcend the ordinary limitations of time and space." (Ibid., Page 176, 1991)

When a crop circle forms in a wheat field, the affected plants become a subset of the total crop. They develop their own resonance and memory of the event. Although the design varies from one formation to another, the memory of compliance, of lying down in response to some signal, becomes part of the morphogenetic field of wheat. All plants have more in common with each other than they do with animals or people. Therefore, the memory of crop formations reaches into the greater morphogenetic field of plants that includes more than just than one type of grain. It unites various crop plants with each other. The memory of crop circle formation thus wafts through the fields within fields, worldwide.

Each time a habit is repeated it becomes stronger. We have seen the proliferation of crop formations, noted they are becoming more complex and their distribution is increasing around the Earth.

The cooperation of the plant kingdom in creating crop circles can be considered a habit acquired morphogenetically by plants; thus, crop formations demonstrate morphic resonance.

CROP CIRCLES AND OTHER PHENOMENA

It is foolish to be convinced without evidence,
but it is equally foolish to refuse to be convinced
by real evidence.

—Dean Radin

Crop circles are just one of the phenomena that mark our time. I believe there is a relationship between the arrival of the circles and the frequent sightings of UFOs. An acceptance, at least at the level of imagination, is growing that beings from another dimension are interacting with humans.

UNIDENTIFIED FLYING OBJECTS AND E.T.s

Our sense of the material world is being stretched by spontaneous, usually brief, penetrations of our space and time by craft of unknown origin. We label them UFOs, or Unidentified Flying Objects. These craft appear in a multitude of forms, with capabilities such as direct vertical high speed ascension, improbable twists and turns, static hovering without rotors, flying without sound, the emission from and return to them of smaller vehicles. a projection of exceptionally bright lights, and instantaneous disappearances. Photographs taken of them by witnesses of UFOs have withstood the test of authenticity. Speculation that we may ourselves be producing craft with unfamiliar capabilities as a result of reverse engineering comes from knowledgeable insiders such as Col. Philip J. Corso. In his book,

The Day After Roswell, Corso describes his work in the higher echelons of the Pentagon after he was ordered to distribute among American industries various technologies from downed spacecraft for reverse engineering or further development. He was not to divulge the source of the information to the manufacturers. (Corso, 1997)

For years, people have seen UFOs in the skies of Southern England. An outbreak of sightings around the Salisbury Plain preceded the crop circles in the same area. Since around 1980, UFOs have continued to be associated with the annual appearance of crop circles.

Steven M. Greer, an emergency physician from North Carolina, is Director of The Disclosure Project and is also its spokesperson. He is a frequent visitor to England where he has conducted experiments to contact extraterrestrial intelligence in an effort to explain the source of UFOs. Greer extended his observations to include the crop circles.

Freddy Silva, George Wingfield, Linda Moulton Howe, and many others involved in researching crop circles, state their belief that the Circlemakers are not human. Silva writes that he thinks an extraterrestrial race are creating the beautiful images in our fields.

Linda Moulton Howe, in the first volume of her book, *Glimpses of Other Realities*, has included images of various E.T.s provided by contactees. Some of them are the familiar little four or five foot greys with huge eyes who wear skin-tight silverish suits. More witnesses report seeing this form, which might be bioengineered semi-robots, than any other "visitor" from beyond our known world. Howe has written, "One speculation has been that the UFO intelligence might be monitoring the mysterious force responsible for the worldwide crop formations." (Howe, p. 40)

At the International Conference of the Mutual UFO Network held in Albuquerque in 1992, Howe presented slides of drawings and paintings by "abductees" showing the appearance of their kidnappers. The remarkable aspect of the slides was the variety of the images, but even stranger was that similar images were recorded by witnesses in widely separated countries.

The abduction experience is a phenomenon related to UFOs that has been reported around the world by apparently stable people. John Mack, the late psychologist at Harvard University, had the courage to study a number of these cases. The memories of the subjects have so many points in common that Mack believed they constitute evidence of actual events. The trauma of abduction is on the increase in our society. Mack wrote, "Abductees speak frequently of being taken into another dimension or plane of reality with different properties. The idea of other dimensions that are not detectable by our instruments or knowledge of mathematics has also gained currency among physicists." (Mack, 1999, page 55)

Information regarding UFOs and their interaction with humans was presented at the Mufon conference by Vladimir G. Ajaja, Ph.D., who was then the chairman of the UFO section of the USSR scientific and engineering societies' Committee of Energo-Informational Exchange. He organized the Moscow Commission on Anomalous Phenomena in 1985. Speaking through an interpreter, Ajaja reported on a disk-like craft that landed and was seen — and was briefly mentioned at the time in our own newspapers — during the preceding year by the observers in Tblisi deep inside the former Soviet Union. The occupants that stepped out of the craft were described as nine feet in height, walking on two legs, with the characteristic features and greenish color of insects or reptiles, rather than humanoids. Such creatures were described again by Linda Howe in her round-up of physical beings seen by American witnesses in connection with space craft landings in Georgia and California.

Despite hundreds of stories about sightings and witnesses, Howe said at MUFON, "We are in denial." She speculates that abductions may be for a genetic purpose, to insure the survival of an extraterrestrial population, one whose DNA "doesn't replicate well," by mixing human DNA with theirs.

Raymond E. Fowler writes about E.T.s in his documentation of first-person experiences by abductees who relate that they have met The Watchers, the large figures mentioned above, aboard spacecraft. In one case The Watchers referred to themselves as "The Gardeners of the Earth," and said they are the Sky Gods of our legends. In a message quoted by Fowler from abductee Betty Luca – a graphic artist who is blessed with a photographic memory — she said, "...they are the caretakers of nature and natural forms — The Watchers... They love the planet Earth, and they have been caring for it and man since man's beginning. They watch the spirit in all things... Man is destroying much of nature." (Fowler, 1989, p. 171)

The Watchers, who are mentioned in the Bible, The Book of Revelations, The Dead Sea Scrolls, The Testament of the Twelve Patriarchs, and other ancient texts, are always described as of great size, with white hair, wearing white robes, and surrounded by a golden glow. (Fowler, 1989)

Fowler writes scrupulously and thoroughly about his chosen subject of abduction experiences. Betty Andreasson Luca told of her abductions in characteristically graphic detail, which Fowler records from transcriptions of her hypnosis sessions. He follows these descriptions of her experiences with comparisons to ancient scripture and other literature, and he also cross-checks her accounts with reports from other abductees.

Betty Luca's observations offer a pertinent piece of supportive information related to the crop circle enigma. She describes luminous balls of light that she saw aboard a spacecraft more than once in the many abductions she experienced. She asked her abductors about the balls and was told that they are used to store intelligence. If balls of light often seen in the fields when crop circles are found are the same as Betty described, they could contain blueprints for the crop formations.

Abductions have a pattern, not unlike the patterns experienced by people who go through a Near Death Experience. Abductees feel themselves lifted from their sleeping or hypnotized bodies into a craft. They are examined, sometimes painfully, by small grey figures. During physical examinations, abductees say that greys take samples of bodily fluids, sperm, and eggs, which is a type of "farming." Apparently, the E.T.s are ahead of us in genetic engineering. While we are just arriving at the point of cloning, they are creating hybrid beings with characteristics that might be needed for their survival. Abductees find marks, cuplike in shape, on their body suggesting probes were made of their tissues. They discover a variety of implants in their noses or other bodily areas, which are probably tracking devices, making it easier for their captors to find them for repeated abductions. Abductees experience a loss of time, but they learn that off this planet there is only timelessness. Betty describes being taken through a "doorway into another world."

We humans experiment with creatures we think of as lower than we are on the evolutionary scale. We collect samples of their bio-material for our own purposes. We subject helpless animals to chemicals, cosmetics, drugs, and operations before we apply these materials and processes to ourselves. We reflect a relative indifference to the individual animal's experience of undergoing our treatment. Therefore, it is not illogical to compare reports of abductions by E.T.s to scientific study of animals that we ourselves conduct.

Betty used words and drawings to depict the cigar-shaped huge Mother Ship that she was taken to via a smaller disk craft. She described a complex of tunnels hewn out of solid rock, and she indicated that this headquarters of the visitors was an unknown place on Earth, which may be in a dead volcanic crater. Trained "remote viewers" have reported similar sites underground on Earth as shelters where another race is living.

The eeriest aspect of Betty's reports is the precision of her artwork that resembles mechanical drawings. Her drawings of the machines and E.T.s she encountered project an exactitude that is hard to refute.

Stories of an adjacent race that shares the Earth with us have been in human thought for centuries. Though usually invisible, these other creatures reveal themselves occasionally to special people. In every country, over eons of time, reports of little and large creatures that are not recognizably human have had a role in myths and legends. In Polynesia, reports of a lost continent called Lemuria are accepted as factual. When Lemuria disappeared, remnants of the land were left as islands, whose early, small inhabitants are known as Menahunes. In Ireland, the little people are Leprechauns. In Persia, they were Peris. Western fairy tales are replete with ogres, dwarves, gnomes, fairies, sprites, and elves. Maybe they exist. Scientists have proven that legends are often derived from an oral tradition based upon human experience. The discovery of Troy was made by reading myth as factually accurate and tracing the site from the story to its source.

11. *The Face* Chilbolton, Hampshire, 2001
Photograph by Steve Alexander

12. *The Code* Chilbolton, Hampshire, 2001
Photograph by Steve Alexander

Linda Howe quotes herself on the back of her book, "We are moving from the paradigm that we are alone in the universe to a new one in which we are not alone and something out there is interacting with us, our animals and our plant life, *forcing* glimpses of other realities upon us."

Fred Alan Wolf, physicist and writer, said to Howe, "Anything that forces itself upon us, that comes into crop fields, pastures or bedrooms without asking permission *and receiving permission* — in my book, it's dark!" (Howe, p. xiv)

Keeping in mind that there is more than ample evidence of an intrusion into our dimension by creatures and craft from some unknown source, I will also consider other possible agencies for crop circles, in light of our greatly expanding notions of what consciousness includes, but I withhold my opinion about what is light and what is dark. Some years ago, the late Dr. Alton Christensen, a medical doctor and a shamanic healer, told me something unforgettable about light and dark. He noted the increased crime wave in Santa Fe, New Mexico and pointed to the influx of light-seekers who apply many techniques for engaging the lightness within. According to Alton, where there is literally too much light, nature will provide enough darkness to regain the balance that is necessary. His solution to crime, was for each of us to look into our own inner darkness and claim it so that we would not become responsible for another person entering the darkness on our behalf. (Nelson, 1994) At this point, we do not know if the aliens reported to us by sane and trustworthy people are good or bad, just as we cannot characterize human beings in such terms.

In 2001 new evidence that we may have received a response from an intelligent source in space came into the field near a radio telescope at Chilbolton in England. First to appear was a rectangle that framed a human face, formed with light and dark circular forms, resembling pixels. The image was strangely like a portrait by the artist Chuck Close. Soon thereafter, another rectangle arrived beside the first. It held a coded message that followed closely the form of a coded message sent out by the United States from the radio telescope at Arecibo, Puerto Rico, in 1974. Carl Sagan was one of the designers of that original message, which included binary code for the elements in our human bodies, data about DNA, a scale diagram of a human being, a diagram of our solar system marking Earth's location as third planet from the sun. In the crop formation the symbols for elements of life included silicon. The DNA diagram had a third strand. The being's scale was small with an enlarged head. The star system, which logically should reflect its origin, was shown as having ten planets. In Sagan's message, the third planet from the large star was raised. In the crop formation, the fifth, sixth and a multiple seventh were raised. (Plates 11 and 12, pp. 66-67)

Could the Chilbolton crop formations be genuine? Jay Goldner makes a very strong case for their authenticity in his *Messages From Space*. He traces earlier related formations that seem to be notifying observers that there is to be a forthcoming message of true import. Marshall Masters, on www.yowusa.com calls this pair of formations The Smoking Gun. He cites a homemade video from Maurice Osborn that convinces him of the importance of recent coded messages, in particular these from Chilbolton and a formation at Crabwood, which is discussed below. The point made in the long article on this website that stays glued in my mind is that there is a series of formations whose coded messages, seemingly meant to be considered together, arrive in a small window of time each August.

After Chilbolton, another significant message in the series arrived during the 2002 season, marking it as one of the most intensely symbolic on record. On August 15th near Pitt in Hampshire, a multi-part symbol was found just over the hill from Winchester Cathedral, in a field lined on one end with radio transmitters. In what

became known as the Crabwood formation, a tightly woven "serial spiral" unfolded from the center of a circle and along its path were small blocks of upright and laying crop (light and dark) that suggested a digital code. Marshall Masters and Robert Heger, on the yowusa website, August 18, 2002, presented a detailed discussion of this mystery. They said that, "...we have been given the key to facilitating communication with extraterrestrials in a very clear and unequivocal manner." And, even more definite was this statement, "The primary purpose of the Crabwood formation is to show us how to establish a two-way dialogue with an off-world race." (Plate 13, p. 70)

In a succinct discussion of the "message" in the circle, the authors compare it to the format used by DVD players. A DVD is a type of CD-ROM, whose appearance under magnification resembles the code in the crop formation. The task was to translate the binary code and then to create a suitable reply in the same code. It was not long before the following translation appeared along the Internet.

"Beware the bearers of false gifts and their broken promises. Much pain but still time. Believe there is good out there. We oppose deception."

Accompanying the circle in this outstanding pattern was a profile face that resembles the famed Greys, who have been reported often by those who have had encounters with beings from space craft.

August, 2002, held another communication in the fields whose timing was precisely attuned to an event on Earth that was not widely reported or understood. On August 9th, the United States Navy was given permission by the American government to start a planned program of oceanic sonar, apparently on a worldwide scale. Within just a few days, dead dolphins, whales, and squid appeared on beaches. It was said that the brains of the squids had exploded. The thought was circulated on the Internet that the deaths were caused by the sonar program. A lawsuit was filed against the sonar experiment and a plea was widely circulated on the Web to protest the program. On August 14th, a crop formation was reported near Alton Barnes in Wiltshire that featured a vesica piscis of two overlapping rings on which there were fins and a sleek bulging shape; the crop circle is known as the Dolphin formation. Within the enclosure made by the two dolphin shapes there was a solid circle we could interpret as the Earth and around it were three narrow rings that I interpret as echoing waves sent from a sonar device. In this instance, the beauty of the formation and the intent to convey information are in pure harmony. (Plate 14, p. 71)

PERHAPS: WE WERE SEEDED BY E.T.s

An essential question to ask is one that is taken seriously by some scientists: Were we seeded by another race? Though it may strike the reader as "far out" and best left for sci fi movies, the theory that the basic DNA of all Earth life was seeded deliberately by an advanced race of beings who have been manipulating our evolution ever since, offers a succinct explanation for the anomalies abounding in our time.

Astrobiology is a new field that encompasses the search for alien life and also the answer to the question, "How did life start on Earth?" In "Netwatch," edited by Jocelyn Kaiser, (in Science, Vol. 288, May 12, 2000, p. 923) an announcement was made for two websites dealing with this subject. See www.astrobiology.arc.nasa.gov, the site of NASA's Astrobiology Institute, a collaboration of eleven institutions; and www.astrobiology.com is the nongovernmental site for Keith Cowling and other links. Perhaps it is understandable that these websites offer little hard technical information "as for the moment only Earth is known to harbor life." Institutes and websites demonstrate that the subject merits the dollars and interest of both government and civilian researchers.

13. *Crabwood Face and Code* Near Winchester, Hampshire, 2002
Photograph by Steve Alexander

14. *Dolphins* Alton Barnes, East Field, Wiltshire, 2002
Photograph by Steve Alexander

Linda Moulton Howe writes, "It is possible that all life on the planet was seeded by an advanced intelligence from this universe or another which is still monitoring its garden. The idea of extraterrestrials, or other dimensionals, 'planting' life here was first posed by Nobel Prize Laureate chemist Svante Arrhemius." (Howe, 1993, p. xi) The implication of this comment is that life is not an accident. Howe quotes Fred Hoyle who ironically said that deriving life from the primordial soup is about as likely as sending a whirling tornado into a junkyard and coming out with a Boeing 747.

We have to look at how we would go about creating life, starting from scratch, with the level of technical knowledge that we have today. First, we would assemble materials we know to be needed and then we would try to instigate the combination to produce a cell, which we would jumpstart into dividing and developing. We would use ourselves as the pattern to follow. Using the holographic model as a comparison, we see ourselves as the universe in miniature. The Hermetic adage "As above, so below," tells us there has to be a relationship between the method we would use to create life and the one Creation followed. In no way could we count on randomness to favor and abet our endeavor; it does not fit the model.

All of life on Earth shares a single genetic code — DNA. Howe points out that Dr. Francis Crick, co-discoverer of DNA in 1962, suggested that the uniformity of DNA might represent "a clone derived from a single extraterrestrial organism." (Ibid. p. xii)

Developments in biotechnology have been racing ahead since 1962. DNA is yielding its secrets in our laboratories. We have already cloned living animals from individual cells. Cloning another human being is, for the present, officially banned in the United States, but we know from experience that humans will do what they are capable of doing, eventually. Cloned people are almost a given in the not very distant future.

We are, like the E.T.s reported by Betty Luca, already experimenting with growing and harvesting body parts for substitution in aging bodies in order to prolong life, at least for those who can afford it. Our abilities to manipulate the life force of animals, plants, and cells is already awesome. Ray Kurzweil writes, in *The Age of Spiritual Machines*, "As technology is the continuation of evolution by other means, it shares the phenomenon of exponentially quickening pace." (Kurzweil, 1999, p. 16). Rapid acceleration in the biotechnology field is a source of worry among our ethicists. Just where are we going with genetics? Perhaps our technical ability is threatening to our keepers.

The Pandora's Box in our future is a combination of advanced computer technology, nanotechnology, and bioengineering, in the form of thinking machines, artificially made by humans, but which then overtake humans. Kurzweil projects that in less than a century, there will be no clear distinction between humans and computers.

Meanwhile, our engineering ability is leading us to interplanetary and galactic travel. Conceivably, in our future, we could leave our planet, roam space, and eventually plant our seed on another planet. Indeed, Stephen Hawking has warned humanity to begin seeking a possible new home on Mars or the moon so that when Earth no longer can support human life, there will be a place to colonize. Since we have evolved to our present level, it is reasonable to think that a race only slightly ahead of us in computer and biotechnology could already have designed thinking robotic near-living beings that behave as the E.T.s are reported to do by abductees and contactees. These creatures are, we have been told, carrying out the intentions of their masters when they collect specimens and manipulate biomaterials from Earth to create hybrids. Perhaps E.T.s, in their zeal to make use of their own inventions,

allowed themselves to become infertile. Are they aware that we are heading down the same road when we neglect to protect ourselves from dangers of our own making? Our hubris can be our undoing. If E.T.s require repeated refreshment of their own DNA, then our actions have a direct effect on their future as well as our own.

In the prevailing world view, E.T.s are discounted as dreams, hallucinations, or projections by the victims of abuse who redirect their remembered horrors into these stories, or into the creation of multiple personalities. Until a sufficiently large number of well-placed individuals have an anomalous experience, the attempt to discount reports of mysterious events will continue. The scientific establishment did not think it was possible for motorized heavier-than-air craft to fly, until the Wright brothers did so in 1903. Before gorillas were discovered and captured, they were said to be mythical. One of the arguments given to dispute the existence of gorillas was that none of their bones had been found. Today, we read and hear the same thing about E.T.s and yetis. In one account I have read, the author asked what I find to be a basically inane question: he wants to know where are the artifacts from abductions to spacecraft? If a person were to find himself or herself in an abduction situation, under mental and physical control by aliens, being experimented on medically, just how would this helpless person snatch a map, a laser instrument, or a loose object from the ship? The wonder is that they are cogent enough to sketch and tell about their experiences. There are good arguments for doubting a few stories that may have been inspired by "me-tooism" but it is a bit of a stretch to doubt hundreds of stories from different countries by reputable people who describe the same or very similar experiences. Behind the policy of casting doubt on the reports of not-of-this-reality events, is a whole level of officialdom in more than one country that has vested interests in arbitrating what is accepted as "true." On the subject of E.T.s, UFOs, or even of fairies, I think it is prudent to keep open to the fact that each of us knows at first hand only a tiny part of the spectrum of potential reality. We will be wise if we do not rule out anything because we are told to do so.

EXPANDING AWARENESS AND THE CROP CIRCLE ENIGMA

*Before us lies a new ocean, the ocean of endless possibilities
and applications, giving the potential for the first time
to manipulate and mold these forces of Nature to our wishes.*

—Michio Kaku

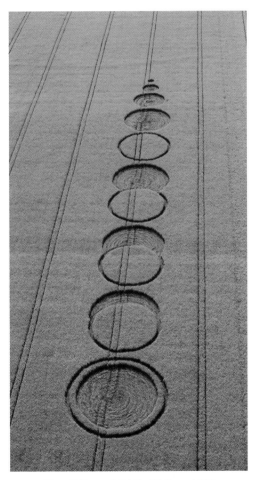

15. *Eclipse* Middle Wallop, 1999
Photograph by Steve Alexander

The mystery of crop circles has, for me, been the nexus of speculations involving all aspects of my curiosity. This book is a personal record that explores some of the areas I think are related to the phenomenon of crop art. It is, finally, a "construal," which is a term I first read in Briggs' book *Fire in the Crucible*. He borrowed the term to explain his own way of collecting related material around his central theme of the genius. He does not say that he is presenting a theory, but rather, he writes, his work was a construal that can give a "useful orientation into what is going on." (Briggs, p. 14). I believe that I have construed the data about crop circles as an outgrowth of what I have learned from prior and on-going study. In this chapter, I refer briefly to a number of contemporary speculations and explorations that relate, I believe, to crop circles.

After all considerations are made, genuine agriglyphs are still a mystery. Potential Circlemakers are equally bizarre no matter which ones we favor. Are they E.T.s who travel miraculously across vast distances to continuously supervise Earth? Are they spirit creatures, devas, sprites, fairies, gremlins, and gnomes who have always inhabited our Earth, in another dimension? Are they other versions of ourselves living on a different Earth in a parallel universe? Are crop circles the result of our own consciousness interacting with higher dimensions of itself? Our use of

the words consciousness and mind constantly overlap. Mind sustains the universe we inhabit. It fills all of what we know as space. Cosmic mind is in each of us and we are in it. So, we can wonder, does anyone originate an idea? At our level of daily consciousness, are we creating or are we *receiving* inspiration?

I will return to the word noospherre, introduced by Teilhard de Chardin who told us we are connected to a shared level of consciousness. He posited this level as beyond our bodies, higher, ascendant, in a sphere enclosing Earth. Carl Jung theorized there is a level of awareness seemingly below our daily consciousness that joins all minds together in a collective unconsciousness.

Wherever human wisdom, memory, and intelligence are stored, it has a communal structure. As our vibrational frequency alters, our consciousness screens out daily concerns and becomes receptive to input from the communal memory bank: therefore, we could say that thinking is of different orders, depending upon the frequency of mental activity. Individually, we add to the whole of human thought, but something "other" must be guiding the noosphere. Our progress as a race appears to be directed intentionally toward a preconceived goal. Whenever information is needed for advancing our state of civilization, it appears. We find evidence of this in simultaneous but nearly identical discoveries made by people who are at a distance from each other.

Collective discoveries and new electronic technologies have expanded our relationships and created a widening field of potential contacts among people who may never actually meet. In less than twenty years we became linked in a global web — the Internet. If we are, as shamans and some scientists believe, the neural network of the Earth, we are now able to constantly fire messages into and receive instantaneous information from all parts of the network. Thus, through our communication, Earth/Mind is vibrating ever faster.

Crop circles may be signals from our programmed evolution telling us we need to speed up our transition to a more connected global society, perhaps because the more connections we have with one another the less likely we are to harm one another.

In significant ways, the future of the computer is identical with the future of humans. Michio Kaku, in *Visions*, projects the twenty-first century in terms of microelectronic and other scientific developments. By 2020 he says that microprocessors will be as cheap and plentiful as scrap paper. Our environment will be completely computerized and voice or body-heat activated. Invisible computers will eventually converse with each other, creating "a vibrant electronic membrane girding the earth's surface." (Ibid., p. 44)

Barring such possibilities as nuclear war, a pandemic, or the collapse of our environment, Kaku tells his readers, our progress will include the continued decoding of DNA until we have mastered the "Encyclopedia of Life." Genetics will lead to curing cancer and other diseases. From 2020 to 2050, the human race will become more and more blended with computers, leading to the extension of life and a planetary culture. (Kaku, 1997, p. 44) "In the past, we could only marvel at the precious phenomena called intelligence; in the future, we will be able to manipulate it according to our wishes." (Ibid., p. 8)

Since 1984 in Austin, Texas, Cycorp Inc. has been programming a database named Cyc, (pronounced "psych") to teach a computer common sense. (AP news item, *The Washington Times*, June 10-16, 2002, weekly edition) Among the 1.4 million truths and generalities the programmers have fed to Cyc are: "Creatures that die stay dead. Dogs have spines." Doug Lenat, founder and president of Cycorp, said, "What people are able to do on a day-by-day basis could be dramatically increased if we are successful." The on-going artificial intelligence effort has now opened a Web link for the public's interaction.

The Cyc initiative bears out Kaku's theme that we are gaining control over our planet and life and mind, but we are also transferring intelligence to machines. In the predictable near future, we will have machines that are fully capable of artificial intelligence, including logic. From there the next step is to create machines that are equipped with artificial mind, able to make subtle distinctions and creative responses on their own. We will embed computers in our bodies to expand our mental acuity, remedy genetic defects, and forestall the destruction of aging — and also to make us controllable from a distance! We are poised to rapidly progress in our chemical/genetic/electronic inventions. Ahead, says Kaku, lies synergy in which quantum physics, biotechnology and micro-electronics merge. "We still must determine the nature of consciousness and prove the superstring theory," he cautions, but he says it in an optimistic voice. (Ibid., p 9)

PARALLEL UNIVERSES

In theory, parallel universes exist alongside ours and may even occupy the same space at different dimensions. A development of the string theory posits that there is a megaverse in the fourth dimension that includes our universe and at least three others to which ours is connected collectively and individually. Tachyons are hypothetical particles which can theoretically move through black holes from one universe to the other. We ourselves may exist in any or all of these universes simultaneously as either discarnate or incarnate beings.

Fred Alan Wolf (well-known for his role in the film *What the Bleep Do We Know?!*) is both a physicist and an initiated member of a South American shamanic tradition. His is a unique voice describing the interface of mysticism and science. In *Parallel Universes*, he states that our doppelgangers are in communication

with us. He reminds us that Jane Roberts, in the channeled voice of Seth, delineates how the alternate versions of ourselves might behave. She has said that every decision not chosen here is acted out in an alternate universe. All the possibilities we face become manifest somewhere. Wolf equates choice with consciousness. Each time we choose, we display consciousness. "...the mind of any sentient being that is capable of perceiving a reality is capable of reaching into parallel universes and performing the task of choosing that reality." (*Parallel Universes*, p. 98)

Max Tegmark, in his article "Parallel Universes," (*Science*, June, 2003) asks, "Is there a copy of you?" He addresses the overlapping interests of physics and metaphysics in this quote:

> By this very definition of "universe," one might expect the notion of a multiverse to be forever in the domain of metaphysics. Yet the borderline between physics and metaphysics is defined by whether a theory is experimentally testable, not by whether it is weird or involves unobservable entities.

George Johnson, in the *New York Times*, on Sunday, April 4, 2000, writing about Dr. Lisa Randall, of Princeton University, and Dr. Raman Sundrum, of Stanford University, describes their theory that many three-dimensional universes are floating like bubbles in 4-D hyperspace. The universes, of which ours is one, are surrounded by membranes, which they call "branes" for short. Each universe is ruled by different laws of physics. "...the various island universes would be inaccessible to one another. But the tantalizing prospect exists that each would be able to barely sense the other's presence through the weak tug of its gravitational pull." The theory may help to explain the riddle of physics: the speculation is that 90 percent of the universe is invisible matter that neither emits nor absorbs light. Dark matter is evident only through its gravity. In the Randall-Sundrum theory, the source of this dark matter might be "trapped on another island

16. Lydia Ruyle *Love and Blessings* (Matsuro Omoto's Water) Handmade paper
Avebury, Wiltshire, 2005

17. Lydia Ruyle *Mandelbrot Black Madonna* (Fractal) Handmade paper
Ickleton, Cambridgeshire, 1991

universe, with its gravity, but not its light able to cross the fourth-dimensional divide."

Should this theory prove to be true, Johnson writes gracefully, "each kind of particle making up the universe... (could be) described as a different note produced by tiny superstrings vibrating in nine-dimensional space. This picture includes matter-making particles like the proton and neutron (components of the core of atoms) and force-carrying particles like the photon (the conveyor of light) and the graviton (the conveyor of gravity)."

I would like to suggest another wave of energy particles, which I call *intelligons* — purposeful thought waves moving from one aspect of Creation to another. Intelligons able to seek out receptors in designated receivers might pass through a "brane" from universe to universe. We are constantly receiving thought waves; some of which may not originate in Teilhard's noosphere, perhaps because the noosphere is more inclusive than Teilhard described. Rather than being an outer sphere of thought encircling the Earth, it might be a higher dimension, beyond the fourth dimension of time. Indeed, the noosphere might be the all-pervasive creative dimension of consciousness that is the matrix of Creation itself.

When we conjoin the Randall-Sundrum bubble-filled fourth dimension with Bohm's concept that consciousness fills the plenum and it preexisted, prior to any form of energy or matter, it seems that our physicists are creatively constructing new models of a megaverse which allow for some kind of consciousness transfer from one universe to another.

Barbara Marx Hubbard, in a conversation with Jeffrey Mishlove, said reverence for Gaia as Goddess is reactionary. Instead of going back to Gaia, she suggests moving forward to the Goddess of the Noosphere, who accepts all progress gladly and lends guidance as we continue our human journey toward self-actualization. Hubbard promotes a vision of Conscious Evolution, leading to a future we ourselves create. I have adopted her Goddess of the Noosphere as a harbinger of hope.

Fred Allan Wolf reminds us that at the microscopic level, electrons exist both in our universe and in others, simultaneously. He offers this provoking image, "...two or more universes playing together resonate..."

MAYBE: PARALLEL UNIVERSES EXPLAIN EVERYTHING

As, one by one, human beings begin to experience episodes of vibrating more rapidly, and moving into another dimension of awareness even for brief moments, they perceive creatures and craft that are nearly invisible to our human eye while in ordinary states of consciousness. Maybe, E.T.s are not the source of agriglyphs. Another race might share our planet in an adjacent dimension.

Quantum physics is a branch of knowledge birthed in the twentieth century. It underscores many advancements in our thinking that are almost magical. Nothing that seems real is, by terms of quantum physics, really real. It is only a possibility, a potential alteration of energy. Nothing becomes real to us until it is observed. As we observe distant space, we are looking back into time. Therefore, by the act of looking, we are, in a sense, creating or bringing into being what existed in the past. Is someone in our future looking back at us and creating our present reality?

Quantum physics suggests that parallel universes exist, and they might occupy the very same space as our universe. Though hard for us to image, multiple universes could easily fit into a multidimensional model. Anything is possible if we can momentarily lift our minds to a timeless/spaceless state.

Fred Alan Wolf helps to make the concept of a megaverse easier for the lay person to grasp. In a megaverse, all universes began at once, some 15 billion years

ago. Eleven of these universes, Wolf states, may be extremely close to us, perhaps in superspace. He thinks that we can, in altered states or under the influence of schizophrenia, perceive the closeness of these other worlds. He says, in his light and bantering manner of conveying serious information, "...each of these universes fluctuates and each is highly unstable...yet, put an infinite number of these unstable universes in the same place, and voila! — you have a stable universe." (Wolf, 1988, p. 92)

"Quantum physics appears to be telling us that what we choose to observe alters, and even creates, what we observe. Thus in a quantum world view, we have choice — something I see as synonymous with consciousness. In other words, to have consciousness there must be choice. But how can choice manifest? There must be mind...Mind, I believe exists as fleeting energy in parallel universes...all of the results of any choice always manifest." (Ibid. pp. 92-98.

We are attempting to solve the mystery of the crop circles in terms of cause and effect. But, what if the source or cause is a "bleed through" from another universe, a manifestation of a choice made in another universe? We need a new frame of reference to explain the mystery.

Mike Denney summarized Amit Goswami's four statements about the "weird nature of reality in a quantum world," in *IONS Sciences Review* (June-August, 2002, p. 19).

1. A quantum object...can be at more than one place at a time.
2. A quantum object cannot be said to manifest in ordinary space-time reality until we observe it as a particle.
3. A quantum particle ceases to exist here, and simultaneously appears in existence over there; we cannot say it went through the intervening space (the quantum leap).
4. A manifestation of one quantum object, caused by our observation, simultaneously influences its correlated twin object – no matter how far apart they are (quantum action-at-a-distance; nonlocality).

Dr. Paul Pearsall, in his book, *Miracle in Maui* (an update of his earlier *Making Miracles*) relies upon the essence of quantum physics to explain miracles of healing. He also provides a recipe for adapting the secrets of science, metaphorically rather than technically, as a way to miraculously heal oneself. While reading his book, I could not help but translate what he was proposing to the subject of crop circles and that makes me wonder: Are crop circles miracles?

To make a miracle, Pearsall cautions us to remember we are all nonlocal, i.e., we share with the whole of creation the aspect of being everywhere at once. Nonlocality is essential to my thinking about the Circlemakers. *The source of the crop circles and the energy to make the designs might be anywhere in any dimension.*

Pearsall speaks of "observer participantcy" which is the notion that the observer affects what is observed. From the uncertainty principle, Pearsall speculates that "The chaos we see every day is evidence of the constant state of flux that characterizes the universe. All life is an undetermined work in progress." (Ibid., p. 17) Pearsall believes chaos or uncertainty suggests that hope is always available. From chaos, or uncertainty, comes order. (From the uncertainty of their sources, we find crop circles.) Pearsall believes that chaos and crises are opportunities to stir things up to higher and more developed energy levels. His tenth secret is what he calls chaology, the study of chaos. Crop circle development is studded with references to chaology in the forms of fractals – the Julia Set, and the fractal stars that have been documented in the fields of England.

"There are opposites to everything in the universe, and miracles are made *when we remember to draw our strength from a holographic or complete view of life rather than a one-sided image.*" (Ibid., p. 19)

Pearsall goes on to discuss the importance of oneness, the inseparable connectedness of everything in the universe. He says that relationships never die. Everything is in relationship to everything else. This holistic observation applies even to crop circles. Since there is no separation within the web of the cosmos, a source for crop circles – or miracles – can be anywhere in that web. The concept of oneness and nonlocality are closely allied.

As he develops his analogy of miracle-making with the secrets of science, Pearsall follows a path not unlike the one I have traced in this book. He addresses multi-dimensionality and timelessness. The Fifth Dimension, according to Barbara Hand Clow, is one that has gone beyond time and space. At that level, miracles and crop circles may find their origins. Pearsall deals briefly with morphogenetic fields and also with entropy. Of entropy he says, *"We are only falling apart so we can fall together again in a different and higher order."* (Ibid., p. 22) In short, Pearsall's excellent and affirmative book about healing ourselves by making miracles can be adapted as an explanation of the quantum relationship to crop circles.

Seth told us to widen our focus in order to understand the true nature of reality. The scientists who are postulating the "brane" theory have widened our focus to higher dimensions. Mathematicians already have expanded to 12 or more dimensions. Maybe, when we speak of "dimensions" we could just as well call them universes. They may be one and the same. If higher realms and higher universes are just altered states of the ones we know, they might be accessible to us in altered states of consciousness. I believe consciousness is the vehicle for information to flow from one dimension to another in the form of an energy I call "intelligons."

GLOBAL IMPLICATIONS

This present moment, just as these expansive theories are advanced, seems to be an optimum time for us to make the evolutionary decisions that are of such great consequence for our development. Yet, there is a conundrum: in view of our growing knowledge of a cosmic environment that extends into multi-dimensional as well as deep space, how can we be certain that it is we who make decisions? Is an advanced race interacting with us? Is a superior intelligence dropping sequential ideas into our minds, propelling us into the control of a centrist force, an oligarchy either on or off-planet? Conspiracy theorists favor the view that we are being hypnotically led to our own destruction or enslavement.

As they say, even paranoids have enemies. An extraterrestrial race with designs upon Earth, that is manipulating our development, would benefit from our indifference. By exercising patience and coopting our media, outside agents could desensitize our outrage about attacks on our freedom and our privacy. They could promote practices that destroy our health. When the time is ripe, the E.T.s could walk in without opposition. Apathy has already set in, in part due to the success of the New Age self-help movement, which promoted and still promotes a blinkered myopia fixated on the narrow limits of personal concerns, with less and less attention paid to the welfare of society as a whole. Fewer people vote, fewer are willing to take the heat in public life for expressing unpopular opinions. We destroy our leaders through slander and ad hominem attacks from the cowardly position of safety well behind the lines of a bunkered domesticity. As long as we are comfortable, we do not really want to exert ourselves.

An alternate, more positive viewpoint is that the souls incarnated on Earth today hold Atlantean memories and are programmed to avert the disasters that befell

the prior Atlantean cultures. Evolutionary optimists project that we have arrived once more at the threshold of knowledge that could lead to human control of life and we face the same moral considerations Atlanteans avoided to their peril. The information being provided for our guidance is meant to steer us around the tunnel vision which promotes moving ahead technologically in any area, regardless of consequences. A benign intelligence seems to be coaxing us to choose widely among several possible futures before it is so late that we are fatally committed to a single track that could be a dead end for our current civilization. What we choose to develop from all possible electronic and bionic technologies will affect the entire planet, not just our own super-powerful country. The intentions we claim as our own may be manifestations of intentions sourced in our doppelgangers, either on or off planet. Thought is telepathically transferrable from human to human, and possibly by non-human to human. In our daily lives, we can suddenly "know" who is calling before answering the phone or the doorbell. We anticipate what another person will say before he/she says it. We assume, when we begin to speak, that what we are saying will reflect what we are thinking, but often what we say is a surprise even to ourselves. In his *Entangled Minds*, Dean Radin describes experiments that show we have telepathic ability, as a latent skill. Conscious telepathy is unusual today but we might be well-equipped to receive thoughts subconsciously.

Where were we between our last incarnation and the present life we are leading? Perhaps there is a process whereby we live alternately in parallel universes. One of these parallel universes could be the Bardo, the Tibetan word for the location of our souls between Earth lives. Are we somewhere else between breaths and between heartbeats? Are our minds porously receiving input from another self?

The source of information that is being parceled out to us in what looks like a deliberately timed sequence may be the depths of our own minds which we preprogrammed before we were incarnated. Almost all channelers say that we chose to be here at this time, in these families and countries, races, and genders. We may be fulfilling a mission to preserve the human race.

Kaku writes that "...the information revolution is creating global links on a scale unparalleled in human history, tearing down parochial interests while creating a global culture...The information revolution is building and forging a common planetary culture out of thousands of smaller ones." (Kaku, 1997, p. 19)

While we are preoccupied, globalism advances, more or less without evaluation of its effects, because it is occurring in so many directions at once. We already share many core processes that are boundary-free. The entire world relies upon the Christian-based calendar. The Phoenician alphabet is standard for transactions between nations. Arabic numbers are used worldwide. Mathematics, physics, music, and art are universal languages. VISA and MASTERCARD are accepted in every country. Long before the end of the Cold War you could charge a purchase in an "enemy" country and it would show up on your next bill. A global network of observatories is linked via email for rapid confirmation of new sightings in space. In addition to email, we are connected by FAX, television news and programming, and the overriding Internet. A web of connections can be the underpinnings of global peace, or at least detente based on mutual interests. Are we moving in the right direction – how can we know?.

Internet/computer/virtual inventions have speeded the expansion of consciousness, but it is becoming harder to discern the best course open to us. At this turning point, we need guidance in selecting from all possibilities our optimum evolutionary future.

I suspect the outcome of right choices will extend beyond our race, beyond our planet, and beyond our universe, just as wrong choices we have already made that are harmful to us are probably disturbing the

equilibrium of galactic processes. In this moment, Earthlings must be creating a profound alarm elsewhere in the Cosmos. Otherwise, I believe the increased pace of incoming information and anomalies for our consideration would not be happening. Something is trying to get our attention. Crop circles could be signs to help us sift from humankind's manifold theories, concepts, and versions of the truth, those elements apt to steer us in the most beneficial direction.

This line of thought brings us back to the actual images found in the fields all over the world. One would expect, from such an outré phenomenon, absolutely fresh images, never seen before. Such is hardly the case. Agriglyphs are recognizable forms relating to and reminding us of known symbols from a number of disciplines. To recaptitulate:

- Superb renditions of fractals point to chaos theory; perhaps they are a sign that here lies wisdom. David Bohm stressed that chaos is a form of order, susceptible to mathematical analysis.

- The vast majority of agriglyphs are variations of long-cherished circular symbols for totality, for inclusiveness, Oneness. These signs tell us that the chief lesson we must relearn is the interconnectedness of our species within nature, from the microbe to the cosmos. Human separation from nature is a heresy incorporated not only by our world religions but also by the scientific paradigm that grew from religious structures. A vital, inclusive myth would help heal the separation of humans from the natural world.

- A third category of crop circles directs our attention to human interactions. Within this group are the pictograms strung out like sentences of related circles, bars, and forks. The Hopi see in them their ancient symbol whose meaning is taken as the connectedness of all races.

- Fourthly, some crop formations strongly resemble female fertility symbols of the Neolithic period.

The circles may also be a warning that fertility is fragile and needs to be protected.

Crop circles are penetrating our psyches; they are showing up now in advertisements, films, and art. Their mysterious creation suggests our consciousness connects us with another dimension of interactive consciousness in which we take part.

Crop circles coincide with relevant studies of consciousness. Through the work of Candace Pert and others, we have learned that thought is not limited to our brain. Neurons, which engage in thought transmission, are found throughout our bodies. Even our hearts can "think."

The energetics of thinking have effects both inside and outside the body. Thinking is an aspect of the electrical nature of the human body. Around us is an energy field powered by the electric circuitry of our bodies. The field is detectable by Kirlian photography and electronic measurement. The proliferation of sensors — those invisible brain bits that turn on the water in airport sinks in response to our body heat — are based on applied knowledge of our bodily auras.

Edgar Mitchell has written that "Humanity must rise from man to mankind, from the personal to the transpersonal, from self-consciousness to cosmic consciousness." He then describes cosmic consciousness as a state in which "there is constant awareness of unity with the universe pervading all aspects of one's life." He reminds his readers that both Albert Einstein and Sir John Eccles believed there is a transpersonal dimension to creation that is "outside the space-time continuum of the three-dimensional universe and sustains it." (Mitchell, 1974, pp. 31-35)

Genuine agriglyphs seem to be transmitted from an unknown intelligence to the crops themselves. The transpersonal sending mind might be from another dimension. The process of transmission could be telepathic, moving through the noosphere — the collective/universal mind or a discrete portion thereof,

on or off planet — to the receptive consciousness of the plants.

Mitchell treats the potential for telepathic communication capability seriously. "Telepathy demonstrates that there is an informational linkage between people that goes beyond the laws of science..and the discovery of primary perception in cell life apparently extends that linkage downward in the ladder of molecular organization." (Ibid. p. 45)

Referring to the experiments with plants carried out by Cleve Backster, Mitchell says that Backster concluded "there is an undefined sensory capacity in vegetable and cellular life that is akin to...some forms of ESP." (Mitchell, Ibid.) To account for these discoveries, we need to revise our basic image of the universe. In a holistic universe, plants share a form of telepathic awareness with human beings. Perhaps plants, like people, may receive input from doppelgangers of themselves in alternate universes and respond to their message to lie down in a predetermined pattern. As a corollary of that idea, doppelgangers may be sending messages to human artists urging them to make circles or to energize the arrival of circles through the power of their thoughts.

MANIFESTATION

David Spangler is, for me, the expert on the law of manifestation. He writes, "Manifestation is not magic. It is a process of working with natural principles and laws in order to translate energy from one level of reality to another." (Spangler, 1975, p. 3)

Spangler uses the example of an author with an idea that exists at first as mental energy and manifests as a written novel in physical form, in print. He speaks of an inspired artist who must translate the energy of his visual concept into the physical realm through application of paint. Another of his examples involves the emotion of faith leading to praying for health, which then might activate the body to heal itself. One of Spangler's best contributions to the subject is his insight that our speech is a tool for manifestation. As we translate our thoughts into words, we empower them. "We are always manifesting when we talk, and the forms we make visible to others through our speech can reveal much about our own inner states; they can also determine the nature of the world that we experience and of what we attract to ourselves...This is also the reason to avoid purposeless, negative talking. If we dissipate our powers of manifestation on one level, or turn them to negativity, then we dissipate or negate them on many levels... (Ibid. p. 5)

"This is what manifestation is: the working of natural laws of energy exchange and transference within the consciousness of the Whole and through an attunement to the Presence of the Wholeness...It is not a passive state, an attitude of complacent waiting, assuming that life will attend to all one's needs. It is not a magical operation. It is a dynamic state of consciousness." (Ibid. p. 6)

Fritjof Capra quotes Gregory Bateson who proposed that mind is a systems phenomenon that is characteristic of all living organisms; even societies and ecosystems display it. Capra says, "Our attitudes will be very different when we realize that the environment is not only alive but also mindful like ourselves...The fact that the living world is organized in multileveled structures means that there are also levels of mind..." (Capra, 1983, pp. 290-291)

In our lifetimes, we have extended the range of our senses across space. Cameras mounted on human-made machines act as our eyes, showing us the Earth floating in space, the surface of Mars, the hills of the Moon, and the shapes of galaxies at the edge of the universe.

Mankind continuously responds to intense promptings by leaping forward into the unknown. Our own achievements are remarkable. That is our history.

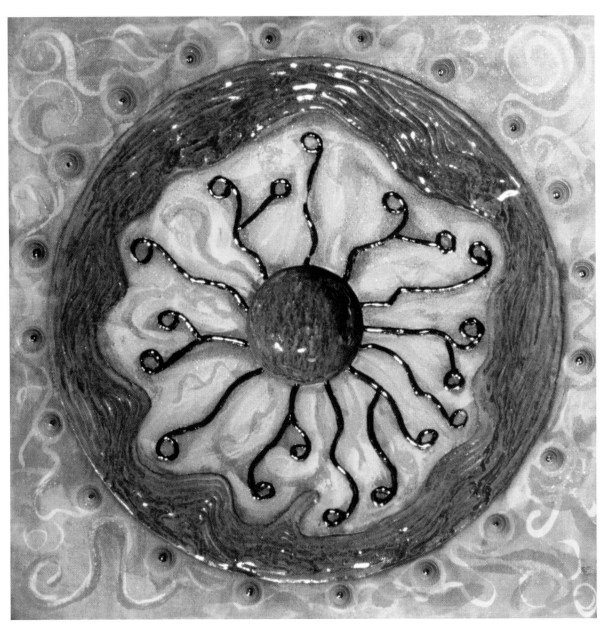

18. Marilyn Christenson *Marduk* (Tree of Life) Clay
Stonehenge, Wiltshire, 1997

19. Pauline Eaton *Primal Symbols* Watercolor
Akin to Crawley Down, 1990

Today, overt anomalies are moving into our line of vision, forcing us to consider a higher order of thought, a multidimensional capacity in ourselves, and a megaverse in which to converse, co-habitate, and soar into the future.

CONCLUSIONS

Thomas Berry helps us keep the present expansion of All That Is in perspective. He writes, "The human is less a being on the earth or in the universe than a dimension of the earth and indeed of the universe itself." (Berry, 1988-1990, p. 195)

Berry speaks of "the spontaneities" within and states, "Ultimately these instincts come from that mysterious source from where the universe itself came into being as articulated entities acting together in some ordered context..."(Ibid., p. 196)

The same inner guidance that we can now rely upon, in Berry's mind, was the source of the initial fireball, and what we conceive of as our present reality is the explication (in terms of the explicate order of Bohm) of the original fireball. There is only one source. To Berry that source is the dream.

"We are, of course, using this term not only as regards the psychic processes that take place when we are physically asleep, but also as a way of indicating an intuitive, nonrational process that occurs when we awaken to the numinous powers ever present in the phenomenal world about us, powers that possess us in our high creative moments. Poets and artists continually invoke these spirit powers, which function less through words than through symbolic forms." (Ibid., p. 211)

We have choices when we ponder the mystery of the agriglyphs. Even if we cannot conclusively prove a single source for them, they may have accomplished their most important purpose because they are forcing us to consider an infinitely diverse and creative matrix from which everything, including ourselves, emerges.

In a holographic universe, each aspect reflects the whole. Artists are sensitive to the creative nature of the universe. If there are other universes, there are other artists who might be doubles of Earth's artists. Artists' counterparts might be inspiring those we call "hoaxers" to create beautiful crop circles that researchers do not consider genuine. Thus, hoaxed crop formations might be creative responses to an impulse from the Circlemakers themselves, from somewhere beyond our dimension, inserted into the Earth plane from our creative counterparts. That would mean agriglyphs are, potentially, an aesthetic exercise by our alter-egos regardless of who actually creates them.

Another explanation of crop circles derives from the idea that consciousness fills every universe; therefore, all beings within All That Is are attuned to the same creative consciousness. Even the plants share in this cosmic consciousness, so agriglyphs may be the response of empathic plants to the consciousness of their counterparts in another universe.

Ethereal beings within our own universe may be the artists of the agriglyphs. The sea of energy that fills the invisible plenum is pure creativity, an energy that gathers itself into matter, into ideas, into inventions, and into beings. Agriglyphs are signs of this universal, or megaversal, energy upon which everything depends and of which everything is made.

The concept that agriglyphs appearing in fields on Earth arise as symbolic messages from nature spirits that dwell at a different dimension from ours is one that appeals to me. Perhaps they manifest as light bodies bouncing about in the fields that have been seen and photographed. They might be the activating energy behind morphogenetic fields. They may be forcing us to pay attention to their existence. Agriglyphs are a call for more cooperation between us and the etheric beings whose purpose is entwined with our own, whether they are devas, E.T.'s or aspects of ourselves.

To fully grasp crop circles and to spread the awareness of their existence, it is contrary in the extreme that we lapse into arguments by taking sides, become proprietary about their characteristics, worry about hoaxing, and generally treat them as a subject under arbitration. The field of study is crying out for a circular approach to the discussion, akin to David Bohm's promotion of dialogue and the Native Americantradition of talking circles as a method for making decisions. In such a circle, everyone speaks. Each speaker is respected. No one has veto power over anyone else in the group. Talk continues in a spirit of peace and interaction until consensus is reached, however long it takes. I sincerely believe crop circles are here for many purposes, and one of those is to direct our thoughts away from linear thinking toward a holistic model. One message of the crop circles is that none of our problems is insurmountable. Form circles, not sides, to deal with the future.

We are in a consciousness revolution. Nature spirits could be supplying conscious energy and cooperation to either produce or stimulate the plant art we call crop circles. Agriglyphs are within a cluster of overt signs that we are moving forward as a species, graduating into a higher level of comprehension and compassion.

The more open and awake we become, the more evidence we discover that the world we inhabit is situated within a totally animated, totally conscious vastness. Crop circles seem to be anomalies – outside our accepted reality; but we have to conclude that there are no anomalies, there are only unexplained aspects of infinite consciousness.

Although mysterious, crop circles are undeniably a new form of art. Circlemakers have achieved their mission as artists by awakening us to the beauty of their work. The images briefly gracing our fields enliven our inner landscape as well, leaving us with traces of wonder long after the harvest. I am grateful for them.

ARTISTS DISCOVER CROP CIRCLES

Art seems to be a spark of the eternal coalesced with a
distinct historic moment, driving artists to do something
that witnesses their depth, that expresses their most per-
sonal and universal insights.

—Alex Grey

In 1997, as mentioned, the Society of Layerists in Multi-Media met in Marlborough for a tour of sacred sites in Wessex and Cornwall led by Isabelle Kingston and Simon Peter Fuller. One aspect of the tour was Isabelle's introductory talk in which she said "It is not necessary to be in England to see the crop circles. Pictures have gone out worldwide and people have received information in the images, whether they realize it or not." She encouraged these artists to help circulate the crop circle designs through their work. When crop circles are reproduced in other mediums, they effectively transplant the information they contain into the memory banks of viewers who may never see a crop formation in a field.

The tour group was inspired by this idea and they responded aesthetically to the designs themselves as one artist to another. The crop formations are captivating, but their relationship to the landscape is a wonder. The Circlemakers show, in most cases, an acute sense of placement and alignment, which are the essentials of composition, and an eye for design. Their craftsmanship is to be envied.

The tour included visits to crop formations. Some of the artists flew over the fields at twilight. A few of them have continued to follow the phenomenon on the Internet since they returned home. At a subliminal level, some kind of psychological mutation seemed to affect everyone on the tour.

Lydia Ruyle, one of the artists on the SLMM tour, has returned many times to England during the crop circle season. She has produced a body of work honoring the designs through her very large handmade paper works she calls banners. Her interpretations are unique artworks in themselves and, at the same time, are expanding the possibility that viewers of her work will respond to the power of the designs just as Isabelle has projected.

On August 12, 1991, near the end of the growing season a dramatic geometric rendering of a famed Mandelbrot fractal image arrived near Ickleton in Cambridgeshire. The farmer harvested it so quickly that few people actually visited it, yet thousands are familiar with it from fine aerial photographs. The formation was immediately recognized as akin to a computer generated diagram of the Mandelbrot mathematical theory of chaos.

Lydia translated the Ickleton formation, which resembles a heart surrounded by smaller circles, as her

Mandelbrot Black Madonna — the Goddess. The silhouetted image radiates energy, both from its shape and from Lydia's creative process. She creates evocations of crop circles with handmade paper by transmuting plants that originally grew in fields into pigmented pulp. The pulp forms not only the sheet of handmade paper, (whose vertical dimension is greater than her own height) but also the form of a crop formation simultaneously. Her circular process, from a crop design that first appeared in fields of plants, into a new image made from plant-based pulp is Lydia Ruyle's unique version of the Layerists' holistic perspective. Although we do not know what creates a crop circle, we do know that they take place in nature. Ruyle has developed an aesthetic analog for a natural event. She says, "I'm trying to translate the energy of the crop circles visually in my work." (Plate 17, p. 79)

The cosmic background of *Mandelbrot Black Madonna*, is a deep, rich black, a color hard to achieve in handmade paper. Ruyle built ensuing layers by pouring thoroughly beaten artist-dyed pulp, using circular gestures. "I also 'paint' with squirt bottles," she says. The fibers tend to clump themselves into little circles, which emulate particles of energy. The contrast of warmth at the edge of the fractal with the deep blues and blacks of space adds to the sense of a figure in flight.

Ruyle lives in Greeley, Colorado, from where she has been an international spiritual nomad for two decades. She teaches a popular class titled "Herstory of the Goddess" at the University of Northern Colorado and she has led YA-YA (her grandchildren's name for her) Goddess Journeys around the world. She is the author of *Goddess Icons, Spirit Banners of the Divine Feminine.* (Woven Word Press, 2002)

On a Gothic Images/Magical Britain tour in 1991, after the harvest, Ruyle saw her first crop circle images at a slide talk presented in Glastonbury where she met John Michell and other key people in the inner world of "croppies." Two summers later when she led her first Goddess Tour, "Women's Pilgrimages to Sacred Sites" in England, some of her tour group wanted to visit a crop circle if they could find one. Confidently, but without any prior experience of doing it, Lydia dowsed a map and directed the bus driver to the road leading to East Kennett Longbarrow. As her group came over the hill, they saw a large formation that Lydia interpreted as a birthing goddess. The episode unfolded so smoothly that she took it as a sign she was back where she belonged in some deep way.

"The images find me," says the artist. "I think they are a sacred language. I see them as sacred symbols of the Goddess, the divine feminine spirit, which exists in ALL. Symbols are universal. They speak to everyone on some level, stirring common memories. They go beyond the rational conscious mind to the realm of the unconscious, where soul memories reside. Most cultures throughout history have used symbols as a tool to unlock these collective memories. I know I have selected sacred images of the world for my art...With my art skills and conscious awareness, I access multidimensionality," she says. "The crop circles have been a gateway for me in my art making and in the stories I tell about the work. The spiritual journey embraces the sacred.... Sacred means wholeness. Honoring the sacred is becoming whole. Art is a soul journey."

Marilyn Christenson, who lives in Albuquerque, New Mexico, is a frequent visitor to the crop circle site on the Web. When she started her work titled *Marduk*, she says, "My intention was to make a crop circle piece in clay, due to Isabelle Kingston's directive that images of the formations should be spread around." In May of 1999, a circle was discovered at Avebury Trusloe, southwest of the Avebury circle of standing stones. Marilyn was intrigued by the twenty small circles on the outside of the great ring in the crop circle and by the branch-like "little roads" within it that reminded her of pathways on a planet. "I was looking for an

image that spoke about the continuous river on the third astroplane where the astrobody goes after death, if the person is eligible to go there." Her inspiration came from Mark Macy's Continuing Life Research program in Boulder. (Plate 18, p. 86)

Marilyn once heard Rollo May suggest that art, in retrospect, can gain more significance as an indicator of some future event. For her, *Marduk* was such a precognitive work. She completed it in June, within a month of the crop circle's appearance on May 23rd in England. Ahead of Marilyn lay the illness and death of her loving partner, Wayne Sweet. After time passed, when she reviewed her work from the half-year before his death, she found new meanings in each piece.

Marduk relates to the subject of passing over. "I didn't know I was going to lose a loved one when I did it," she says. "Maybe, at some level, I was gaining some preparation for the loss to come. Layerists work at this gut level, the intuitive level. After I joined the Layering Society I had a transition, with a maturing of spirit. It was a matter of studying together and alone, and reading, with an intent to practice holism, spirituality and connectedness. Caroline Myss points out that when you leave your tribe and power centers, time takes on a whole new meaning. Time is a tribal and a linear thing. As a Layerist I find time to be more multidimensional."

Marduk is a fine example of Marilyn's clay pieces. Incised symbols on the side panels refer to Earth, sky, plants and humans, the kingdoms that Isabelle Kingston links to the crop circles. Aesthetically, the central depression glazed in a rich blue is both an accurate rendition of the crop circle and a symbol for a possible gateway to another dimension — the route that souls take as they enter Marduk. When they "have accomplished what they need to do there, they might go on to a higher level" by departing through this passage. The twenty little depressions around the circle accurately represent the small crop circles in the formation. The artist explains, "I tried to follow the actual crop circle fairly closely as to design. The waves of the river, for example, emulate the pattern of spirals in the grain. To me, they represent energy and learning centers. They are places to receive knowledge.

"I've tried not to think about the source of the crop circle. I've just been amazed and delighted by it."

Pauline Eaton also lives in Albuquerque, New Mexico. Her *Primal Symbols* is as close as one could come to demonstrating the manner in which an artist exercises the bicameral mind. The painting represents a philosophical and aesthetic synthesis of dualities coming into harmony. "I wanted a design that was about centering. This crop formation had an essence like a figure. It also seemed related to the chakras. Through intuition, I knew it had to be divided down the center," Pauline says. (Plate 19, p. 87)

On the left vertical border are angular symbols, glyphic references to a "crypto-language" and mathematics. The prismatic border serves as a metaphor for the male/animus left-brain. On the right side the forms are fluid, graceful, and enigmatic as a sign of the female/anima right-brain. "In design, I always tell my students to vary the spaces in a work as I have done here with the spectrum and energy pathways."

The center is filled with the large multi-part crop circle formation in which each element has become a signifier of the resolution of duality. The artist explains, "I don't want to be identified with any religion or civilization. I see these shapes as universal symbols. We intuitively understand a circle and a square as having meaning....

"At the base, as in the chakra system and the kabbalistic Tree of Life, there is the foundation of the Earth. Our experience is grounded on Earth. Crop circles appear on the Earth." Pauline shows the noosphere flowing around the globe, which she encloses in a pyramid. Steps rise to the center where the "Jewel Self" is enclosed in an egg. "The Jewel is a symbol of perfection. The soul is like a jewel. The egg is the Greater Self

20. Cynthia Ploski *Restoration of the Holy Feminine* (The Queen) Mixed media
Lockeridge, Wiltshire, 1998

21. Selene Marsteiner *Sacred Dimensions* Assemblage
Various crop circles of the 1990s

or Higher Self. The jewel is within the yoke of the egg, that serves as food for the soul...

"A lot of my work is about the waves of energy that make up everything in the universe. The ground energy is God energy and that manifests as masculine and feminine. Energy fascinates me. It makes up all matter. A larger power out there is capable of things undreamed of; it runs through everything but we are only able to perceive it through the spectrum of manifestation. This power is the source of the crop circles and it carries a message. I like the term Temporary Temples (from Karen Alexander) for the crop circles because it seems to identify the sacred in what is ordinary, such as the crops."

Whatever is making the crop circles, Pauline says, "is like a spiritual branding iron that is imparting and concentrating the energy in a pattern...Jesus spoke in parables so that the people could work out his meaning for themselves. The crop circles are also like parables. They are meant to be looked at but they are not explained."

Cynthia Ploski is the author of a well-regarded book, loaded with useful information and a personal record of her recovery from breast cancer, *Conversations With My Healers* and *Chasing the Magdalene*, which grew from research and journeys in France. She lives deep in the Colorado woods near Trinidad and is a frequent traveler. On the SLMM trip, Simon Peter Fuller told her about his tours in France and the many legends of Mary Magdalene associated with the southern region along the Mediterranean and in Languedoc. "Being in the crop circle "Torus" and meeting Peter, then having him tell me right there about Mary Magdalene in France, reminded me that I had come into a devotion to the White Madonna during my cancer. When I had prayed to her, the Blessed Virgin Mary, I received a sudden electrical discharge that I took to be a healing. Just before going to England with the SLMM group, I had been listening to tapes about Medjagorje, and I was so drawn to feminine healing energy that I was a groping for a fuller understanding of it," Cynthia explained. This episode led Cynthia on a long research quest that is still in progress and it has affected her art.

Restoration of the Holy Feminine is a watermedia collage. "The work links the crop circles with the feminine. They are an expression of feminine energy. The circles are manifesting with subtlety, precision, and beauty, which are feminine characteristics. And, they are on the Earth, which is the Gaia energy," she says. (Plate 20, p. 94)

"The most obvious components of the composition are the figures of female saints which I see as personifications of the Goddesses. They are the ones I have met on my journeys to the south of France. Mary Magdalene with her skull is the most prominent. Sainte Sara, wearing a purple cloak, is a Black Madonna. There are also Saintes Mary Jacoba and Mary Helena, who accompanied the Magdalene when she landed in a small boat on the Mediterranean Coast at Les Saintes-Maries-de-la-Mer. There is an enigmatic stone sculpture of a face next to the bright camera flash. I wanted to show the power of the face from the church in that small seaside town. Sainte Martha is crowned as she appears in her reliquary. On the lower left I placed an image of a holy family, probably Neptune, a goddess, and child from an antique map. My aim in restoring the Holy Feminine is to bring it back into balance in a sacred marriage of male and female.

"Another major element is the water stain in the church at Rennes-Le-Chateau that reminded me of a figure in ascension. The halo surrounding it is from the tea napkin I kept from one of my visits with you, Mary. The papers in the foreground are green-gold and they represent the water and the Earth; the sky is the ascension, and the surround is air, so the four elements are part of the painting. A curving line of crop circles, all from 1998, moves from the left, up into the sky, down

toward Earth and then up to the right, culminating in the Queen formation."

Cynthia's aim in her writing and artwork is to encourage a return of the feminine spirit to world consciousness. "I get bubbly, excited, almost obsessed with learning more about relationships and threads in the old legends, and then going to these places to see what is there. When we are open, ready, and accepting, part of our selves becomes activated, touching in…we are more than we think we are. Part of us extends into and makes a roadway for information, circumstances, and happenstances. The door can be a personal crisis and that acts as a prompter. My line of inquiry fits into the evolution of new awareness. It can't happen without the feminine. Coming into balance is necessary for the evolutionary process to move in the right way. In my painting, I see the feminine energy as loving."

Selene Marsteiner is an assemblage artist who lives in Michigan near Grand Rapids where her husband Ron is a pharmacist. When the Marsteiners walked into the "Torus" crop formation with the SLMM tour group, Selene says, "I did not know what to expect." She was struck by the physicality of the great circle. "Down on our hands and knees for a clearer inspection, everything had an edge." At the precise point where the spiraled crop met the standing plants, the way the individual plants were aligned next to each other, and the way the grain was layered and woven together appealed to her as an artist.

The Marsteiners experimented with the circle. They lay down and felt heat rising from the wheat even though the day was overcast. Selene dowsed a line of energy running through the center of the formation. As the couple began walking the outer pathways of the formation, that seemed almost basketlike, she fell into harmony with the energy of the entire layout. "I wanted to run, just like a child, in and out of the center, careening around the overlapping curves of those rhythmic pathways," she remembers.

Crop circles, in retrospect, made an even deeper impression on Selene. "I felt an opening up to something beyond understanding. The circles involve our collective unconscious and a different dimension. There is an energy beyond our own that is creating them — it's not of human source. It's a form of communication. People either are open to them, or they are in complete angry denial of their creation. There is no middle ground."

Selene has noticed a similarly divided reaction to her three-dimensional work, *Sacred Dimensions*. It affects the viewer, who is either attracted to it or is disturbed by it. The piece exemplifies her use of textures, vivid color, and wit. After consulting an atlas, she built up the central Mother Earth or Gaia shape like a topographical map. The British Isles are the prominent feature. She marked the energy of the Wessex Triangle with a spiral. The globe is encircled with an aura that is a lighter tone than the rest of the background, which she modeled and impressed with circular and triangular shapes. (Plate 21, p. 95)

"I am drawn to the solar shaped formations." From available photographs in books and her sketches, Selene chose five forms that she resonated with to include in this work. She made freestanding images of them from handmade paper, suspended them by a wire, and attached them to the background. They are textured and painted in oils. She cut two other shapes to signify a star and the moon from aluminum. She says, "I had to bring that physicality to life."

Marilyn Stocker is a retired Arts Coordinator for the public school system of Newark, Ohio — but she is still in charge of a youth program for the Ohio Watercolor Society, and she loves the theater. She designs and makes costumes and is 100% involved in local productions of demanding plays such as *Hello, Dolly*. Despite her commitments, she finds time to travel. Her trip to England with the SLMM tour was an inspiration for her paintings.

22. Marilyn Stocker *Celtic Crop Circles* Watercolor
A selection of authentic circles, 1990s

23. Juanita Williams *We're Here* (Torus) Watercolor
Alton Priors, Wiltshire, 1997

"I got a charge from it. It had a different dimension from the usual tour," she says. "I hung on every word that Simon Peter Fuller uttered while he showed us the landmarks in Southwest England. Later, I found similar stones and symbols on the Scottish coastal islands. When I got back to Ohio, I spoke with a man who had seen a flashing light one night near his home and the next day he had gone over to a field and found a crop circle. He does not tell most people about it."

Marilyn's first husband was a liberal Christian minister who was unable to answer a question that haunts her: "Why can't you allow that there are still revelations and miracles?" She has been investigating that possibility in her artwork for years.

In her watercolor, *Celtic Crop Circles*, Stocker combines a well-rendered image of Stonehenge beneath a cluster of whirling circles with Celtic patterns in them. The great stone circle floats like a mirage, free of time and space. The painting has a magical touch often found in Marilyn's work, which I would describe as Mystical Realism. (Plate 22, p. 98)

"I began to remember that in Stonehenge I had found a vestigial roadway that led into the circle, not the tarmac one that you are supposed to walk on, but another one. I wandered off and found a little round stone with markings on it. I felt guilty, but I knew that I had to have it and I carry it with me everywhere. It felt like a signal to me. It has energy and a message for me.

"As I remember the trip and tie it all to the visit to Avebury, I see it not as a single manifestation but a network of associations. The circles are not new in my work. To me they mean motherhood, the female, the Goddess, the solar system, the orbits. The circle is the beginning and the end, the Alpha and the Omega. Circles are also the first image a child makes as a face, with two more circles for the eyes and another for the mouth. I was preconditioned to respond to the circle and the layering of meanings it has. But, the crop circles themselves did not hit me until I was actually there in England. Now, I still have things to say about the inter-related circular manifestation. They are so engrossing. I wonder that there is no Rosetta Stone to interpret them since they seem like a multilanguage.

"In any artwork, you bring your own vision and experience. The less specific an artwork is, the more open it is to interpretation. With multiple references, you get multiple responses. A truly creative piece has an overlay of creative force coming through the artist that goes beyond one's limited techniques. It has to have a spark of divinity in it. I want to communicate through my art the mystery, the humor, the texture, and the multiexperiential parts of life. I want to dazzle with surface enjoyment and lead the viewer to the deeper meaning that is my intention.

"I want to entice, to question. When I show the paintings I did after coming home from England on that trip, I get lots of questions. It is satisfying to me when something I do pulls people in through its content and intrigue."

Juanita Williams is a sensitive who responds deeply to the telluric energies associated with specific locations. In 1984, she attended the first national meeting of the Society of Layerists in Multi-Media, which was held in Albuquerque, New Mexico. While walking through the airport, she says, "I felt an energy I'd never felt before." The powerful attraction to the area continued to act on her long after the meeting ended. She now lives in New Mexico.

Juanita was moved by the first crop circle she entered, and that was the "Torus." She has featured an expressive rendition of it in her fluid acrylic on canvas *We're Here*. She followed her instinct to create patterns that work with the flatness of the picture plane at the same time as certain angle lines suggest depth of space and also her sensation of a light from above the sun, something associated with the galaxy itself, beyond the solar system. A relationship between this light and the

crop formation is implied, but not obvious at first glance. The composition is an interlocking of bright, arbitrarily colored, reductionistic shapes that clearly indicate the terrain where the "Torus" was found and also a time of day. (Plate 23, p. 99)

"My first contact with the crop circle was from the bus," Juanita explained. She took a photograph of it and this painting reflects the perspective of that initial glimpse. She had heard friends rhapsodizing about crop circles and felt drawn to them, but she says, "I had never even been in a wheatfield before and had never wanted to, back in Ohio. There weren't any crop circles that I knew about where I used to live.

" I know if I lived in England, I would check out every crop circle. I was surprised by some of the English I talked to who seemed so blasé and think they are all hoaxes."

Juanita speculates that the crop circles "bring more questions than answers." As a student of esoteric wisdom, she believes we manifest our own lives. She is open to investigations into anomalies. Since we have often shared information about unexplained phenomena, I felt comfortable asking Juanita if she thinks crop circles are extraterrestrial in origin. She replied, "I don't see any other way to make them besides from an outer space source. My own belief is that there are beings in our space other than us. I think there are an infinite number of dimensions. The crop circles are messages. I get different feelings from different ones. We only react to some of them. We are led to the ones we are supposed to see: our group was supposed to go into the "Torus." From a soul level, I think I may understand it, but in my ordinary consciousness, I don't. It was ten times more impressive being in the crop circle than it was flying over it. I brought back a few seeds and I planted them, but they have not grown."

The crop circles themselves seem genuine to Juanita and she says that "when I make an image of a crop circle, I think I'm contributing to its purpose."

Jack Richards is an artist with a wide ranging résumé. For many years, he was a teacher — from elementary to university level — and an exhibiting fine artist, but he is now a partner in a business bringing "green" architecture to inner cities nationwide. They build and landscape areas of infill. On the outside their buildings are in harmony with their vintage neighbors but inside they feature the latest high tech comforts.

Richards commands dexterous skills in arts and crafts. A friend told him he was a Master of Making Things. *Dragon's Foot* demonstrates his facility. He wove flax to make the fringed background of the work. The image of the crop circle is the pictogram predicted by Isabelle Kingston. He worked the design into the fabric with Indian beads as he wove it. Around the base of the piece he has sewn feathers from his pet macaw, Scooter, who molts totally once each year. Jack says he now has bundles of feathers. The law will not allow him to sell a work that includes feathers from an endangered species; even though, he says, people eat macaws in Latin America "like chickens." He either retains the works that include feathers or gives them away. (Plate 24, p. 102)

Jack considers *Dragon's Foot* a "Supplication," in the sense that it is a form of prayer and empowerment. He intends his complex works for protection of the Earth in her various elements. He saw this crop formation with a foot-like appendage in the field below the White Horse at Alton Barnes, in Southern England. The entire area of Wiltshire is so permeated by Dragon Energy that he believes it was natural for him to see the foot as part of a dragon. Dragon energy is associated with water, so a supplication with such a name is also a plea to protect Earth's water.

"My work is intended to gently provoke," Jack has written. "I want my pieces to be talismans of peace, but also to stimulate heightened awareness."

In the late '80s, Jack encountered his first crop formation below Cheesefoot Head in Hampshire. He

24. Jack Richards *Dragon's Foot*
Pictograph Mixed media
Alton Barnes, Wiltshire, 1990

25. Venantius Joseph Pinto *Agrometry 2* (Pentacle) Digital art
Bishops Canning, Wiltshire, 1997

took many photographs of it. The mysterious bowl-like setting, and the huge formation below him stirred Jack as one artist appreciating another, and it also was important to him as a person with a spiritual concern for the planet. He has remained in touch with the crop circle phenomenon ever since and he has painted a series of large images of the circles.

Explaining his reaction to crop formations, Richards refers to the Biblical statement "there will be signs in the Earth," to explain his thought that crop formations are a signal of the "Golden Age of Man." He says that some may call this moment in time the Second Coming. "A percentage of the crop formations are real. They are bringing in a message. Whether we are attracted by it, and want to emulate it in our art, or whether we fear it, the message is still there."

Venantius Joseph Pinto, a resident of New York City, has had a multidimensional perspective for most of his life. The eldest of three sons, he was raised in Bombay, India, in a Christian family originally Goans. The former Portuguese colony was liberated and became part of India the year Pinto was born, 1961. Goan Christians are a minority in Bombay, but Pinto says when he was growing up, "I thought of myself as different rather than separate."

Pinto completed six years of study in Bombay at the J.J. Institute of Applied Art, earning his degree in Applied Art before coming to the United States in 1987. In 1991, he graduated from Pratt Institute in Brooklyn, NY with a Master of Fine Arts degree in Computer Graphics.

Pinto's solid background in design and techniques of applied art became the foundation of his work. He incorporated his art education from India with the potential of digital art and came up with a unique process. "I'd do things in a traditional medium; then at night I'd go to the lab and replicate them through the computer."

Pinto's work includes a wide range of mediums, from detailed tempera illustrations reminiscent of historical Indian miniatures to abstractions, layered in glimmering veils of digital color. He has established a network of connections in the tough, fast-paced business of graphic art. At the same time he is devoted to the reflective, philosophical intimacies of his studio. Wherever he goes, he maintains simultaneously the objectivity of a stranger and the passionate commitment to membership in the borderless world of art.

Venantius Pinto seems to live between dimensions, always aware of more than one meaning to the events of his life. He is and will remain a man of India, versed in her myths and iconography. As a Catholic, he has integrated within himself the heritage of Western Europe. As an artist he looks for content, relatedness, and genuine expression.

"The first thing I felt when I saw the crop circles was that there is some kind of consciousness inherent in them, an intelligence, a mystery, and a humor that is giggling at us. Even if they are made by hoaxers, I'm still seeing a talent and consciousness that is coming through them from outside.

"The geometry is fascinating, especially in the fields. They could have happened on the moors. I ask myself, why are the fields used as a ritual landscape? And I am reminded of Sita, ancient Hindu goddess in the fields, whose independent goddesshood was robbed by the orthodoxy by coupling her with the more contemporary god Rama.

"I think where the crop circles are is as important as what they are. The English fields are so ordered. Where a crop circle appears, it is as though a big hand has embossed them.

"The crop circle is technique on a huge scale. It is very specific. A lot of time has been spent on thinking it out. It forces us to think, too. I see digital artists using techniques inappropriate to the tool and medium, whereas crop circle artists have invented a technique exactly suited to its site and material."

One of Pinto's series of digital prints features crop circles. The shimmering *Agrometry 2* is from this series; it was shown at the International Print Center in New York City. (Plate 25, p. 103)

Mary Hunter was already painting *Offerings I* when she realized that the crop formation she had chosen to include in the work was made up of crescents. "I use that shape in my work a lot, but I didn't think of that when I saw the formation." The crescent is just one of the familiar references that made their way into her painting. (Plate 26, p. 106)

Mary, now a Texan, grew up as an itinerant army brat. During a significant part of her grade school years, her father was stationed overseas. "In Japan back in the fifties, I liked the smell of bamboo," she recalls. In her painting she has collaged bamboo Japanese paper in subtle tribute to that time in her life.

As a student at Incarnate Word College in San Antonio and in graduate school, Mary found she was attracted by a modernist aesthetic. "I saw things in a different way," she says. San Antonio's museums hold a sampling of work by twentieth-century painters, but much of Hunter's inspiration came from books. She developed her own spare style, which also derives from her girlhood. "My work has always been minimal and that is an Oriental quality." For a time she worked with clay and that influence can still be felt in the textured surfaces of her paintings.

Mary's mother's Midwest relatives were farmers. Their rootedness gave her repeated access to fields, barns, dirt, and the odors of growth in their corn fields. In Texas, she has often walked into the cotton fields. Since she toured the crop formations in 1997 with SLMM, her memory holds not only the smell of cotton, cornfields, and bamboo, but also the grain fields of England.

While others in the group were shopping, Mary hiked along the lanes that cross the land adjacent to fields of oilseed rape and wheat. "You could smell the plants and flowers." The closeness of growing plants on those solitary walks has infiltrated her connection with crop circles. The tramlines that form a design element in her painting are accurate symbols of the English farms, but they are also reminiscent of those on her great uncle's farm. The composition of her painting is a mixture of her kinesthetic identification with the site of the formations and also her Catholic religious heritage, symbolized in the chalice.

In England, the very Earth itself seems saturated with symbolism and overlapping meanings. Mary Hunter grounds these elements in an abstract pattern. The artist feels that the White Horse carved into the chalk hill above the field, the chalice, and the crop formation are offered equally to us as gifts. The chalice also is a reference to the visit made by the tour to the Chalice Well in Glastonbury.

Hunter often paints a basic house shape in her work. "It's my symbol for the soul," she says, "but I noticed that there were no houses beside the fields in England. Aerially, you could see vast areas of the patterns of the fields, and you could also see the patterns from the top of Old Sarum and the Tor in Glastonbury."

Over the years Mary has been a dedicated photographer as well as a painter. In England she vividly remembers flying over the fields. "When I felt sick in the plane, the pilot handed me the controls to distract me. It worked, so I kept taking pictures of the crop circles." The photos from that flight led her to the painting of *Offerings I*.

"I didn't know anything about the crop circles until I saw them. It's awesome to walk in them. You get to be a part of them. I feel that everything works together, somehow. I think the crop circles have a purpose, maybe as a symbol to delve further into mysteries or just to be open to everything in our lives. The crop circles are a phenomenon and I don't think we'll ever know where they came from, but they are divinely inspired in some way."

26. Mary Hunter *Offerings I* (Crescents) Acrylic on canvas
Barbury Castle, Wiltshire, 1997

27. Ilena Grayson *Messenger* (Goddess) Clay
Upham, Wiltshire, 1997

Ilena Grayson is a hands-on artist who grew up among a Colorado family of craftswomen who taught her to knit and sew at an early age. Today, every room in her home in Placitas, New Mexico reflects her talents for handling materials. Chests made by her husband Jerry are inset with tinwork Ilena has crafted. She painted them to resemble antiques. The entry wall is a rich leatherish golden hue that Ilena painted in over-layers with texturing. In the garden is a mounted clay reflecting ball that she made. She made the sconces on her walls, too.

Ilena discovered clay during her undergraduate and graduate years at the University of South Florida, while she was commuting, studying, and raising the Grayson's two young sons. She soon found that what appealed most to her in clay are smooth, touchable shapes that are intrinsically organic. Her mature style included swelling vessels of a rich reddish clay, polished to a sheen, and decorated sparely with metallic leaf. The sculptural aspects of clay attracted her and it was a natural development to move from pots to female figures that suggest ancient effigies with varied headdresses rising from simplified body shapes. Her interest in the prehistoric work of cave artists led to a series of animal figures. Rather than subject them to repeated firings, she worked out a similar surface to the one that she produced on her entry wall. She painted fired pieces with layers of colors. In the final stage of the process, she rubs them with steelwool to reveal traces of the colors below. Her inspiration for the treatment came from a visit to the Pre-Columbian Ceramic Collection in the Denver Museum of Art. On the surface of the early works, traces of color remain as well as the patina that comes from having been buried so long before their discovery. Ilena combined all of her personal methods in the *The Messenger*, a horse that is branded on its rump and shoulder with images of crop formations. (Plate 27, p. 107)

"The White Horse is related to the area of England where we toured. I remembered the juxtaposition of the white chalk horses with crop circles in the fields below. I think animals are our connection to the spiritual. They are linked to our souls. When you solicit a response from an animal it is for such a different reason than from a person. The intent is different. It's unconditional love, like with a child.

"I was building this piece originally just to see how big I could make an animal. The idea of marking the animal came from the Plains Indian Ponies. I was familiar with that historical reference. In choosing the marking for this horse, I looked through images of crop circles and was attracted by the simpler, more circular ones."

Ilena identifies with the way Circlemakers have used symbols in their work. "They couldn't have used symbols that have a 'putting off' quality. Even if we don't understand what they symbolize, they needed to be shapes we feel comfortable with, like these smooth, round, womblike forms. These are not fearful or dark. Whatever their purpose is, they apparently aren't negative. I don't see the dark side in them. Art is a form of communication. We all make art to communicate with other people. The Crop Circles are another language — like art and music."

Some artists refer to crop formations but they do not depict them. Either they choose to make art about crop formations minus actual crop designs or they have never seen a formation and depend on their imagination as they contemplate the phenomenon.

Marie Dolmas Lekorenos, an Ohio artist, finds it takes two years for experiences to filter through her senses and into her art. In August, 1999, images appeared in her work that she eventually recognized as related to the crop circles she saw in 1997. She now feels that "Something about being there started me doing lines, dots, and curlicues."

Number One, Cultural Tapestries Series began with random markings, which is part of her ritual effort to reach a subconscious level of mind in the early layers of

a new work. In later stages, after the image suggested its meaning, she made conscious refinements and decisions. She describes this approach as "having a third eye." (Plate 28, p. 110)

On a dried textured gel surface, she incised a crypto-language of dots and x's, lines and winding curves. For the next six months, she pulled it out and studied it, and painted thin layers on it. References in the work are directly related to the history of England whose early kings ruled from Wessex. Architectural forms resemble castles and cathedrals. A seated kingly figure in the lower right seems to be presiding from a throne. Near the bottom of the tapestry are massive figures with facial features that seem like the eroded standing stones of Avebury or ancient statuary. Serpentine lines on the right edge of the work carry dragon energy. A clear circular shape, but not a perfect one — Marie says she cannot do completed perfect circles because they are too limiting — suggests the crop formations. All her circles are either broken or askew, but, there are a lot of them in this "field" painting. "This is what my paintings are about now. They are fields," she said. "The dots represent the little white lights hovering over the fields when a circle comes in."

Marie visualized the piece as the view from a throne, but others sense it has a higher, more aerial perspective. She is petrified of small planes and did not go up for a fly-over while on the tour in England; so the view from the air is one that grows from the piece but was not her original intention.

"I was very much moved by this painting. When I finally finished I knew it was a special piece with a mystical quality. I felt it answered something in me that I had seen but not yet expressed.

"When I was in the crop circle, I felt energy wherever I went. The "Torus" formation was so large that one beam of energy could not be enough to make it. The energy must be in thousands of separate waves. When you get a shock, you feel all these little tingles. I had a course of treatments from an acupuncturist who decided against using needles. Instead he placed a disk on my back that sent many little electrical charges penetrating my skin. I feel the crop circles in the field require an energy (to help form them) in many little pulses, just like that therapy."

Kathleen O'Brien lived for thirty years in Boulder, Colorado before she and her husband moved to a rural location in Kentucky, said to be a former Shaker property that emits perceptibly blessed energy. Her intention is to create a healing center there; she is trained in a number of therapeutic modalities. O'Brien grew up in an artistic family. Her father was an army officer, so they moved from one place to another fairly often. In the '60s she was attending a Catholic girls school in Buffalo, New York when she rebelled against both the church and the military by driving out to Boulder. As coincidence would have it, she arrived on the first Whole Earth Day which José Argüelles helped to organize. The event determined the course of her life which is characterized as a mixing of healing and art. She continues to expand her range in both fields.

The word field is a key to O'Brien's *Map of Earth's Circles*. Her mixed media work was created with the materials she had on hand before she was settled; instead of her oils, she used waxed paper, crayons, oil pastels, gold thread, and color pencils, but her process was the same as always. "After I meditate, I see things developing spontaneously and I let them take me into the work. I allow myself to be okay with not knowing the outcome. I try to maintain that consciousness. If I can do that, I usually like it in the end." (Plate 30, p. 114)

When flying over Colorado, one is struck by the pattern of circular fields below. Kathleen has captured that feeling of flat, American farmland in her work. She has not been in a crop circle but she has been affected by them. They have fed her imagination by acting as a fulcrum for related ideas. The perspective of her painting is from above, looking down on a golden field of

28. Marie Dolmas Lekorenos *Cultural Tapestries* Watermedia
Inspired by visit to crop circles in 1997

29. Kathleen O'Brien *Map of Circles* Watercolor and mixed media
Inspired by vicarious visits to crop circles

circles. O'Brien sees the inner, more colorful rectangle in her piece as the projected map of the Earth. "I decided to add gold thread for energy lines. I don't mean ley lines. At the Damanhur center in Valchiusella in northern Italy, the founder Robert Airaudi taught that there are random energy lines around the earth. These threads look like those patterns of energy that he called 'synchronic lines.' At about the same time that I was painting this, the Shuttle mission was mapping the world."

What do crop circles signify to her? "They were formed energetically by a force that is not human. No tools were used. Perhaps it was a projection of an energy or a thought. Maybe from space beings, but also it could be by Earth beings, the Devas. I believe the circles involve sacred geometry and a depth of relationships. They hold both scientific and intuitive information. The source is more advanced than we are. Creating crop circles is a great way to get our attention. I really think the Devas are making a harmonious picture by causing the plants to lie down in this way. The message in the circles, I feel, is what any truly spiritual message would be: Live an organized, harmonious life."

ARTISTS AS MESSENGERS

Artists are an intrinsic part of the crop circle phenomenon. Essentially, researchers, photographers, artists and journalists, by compiling a permanent dictionary of living glyphs in their work, are carrying the message in the crop circles far and wide. The designs of many formations have already penetrated the subconscious of hundreds of individuals who may never see an actual crop formation. Native peoples recognize the symbols in them as the traditional designs of their ancestors.

The repeated references to water in new circles remind us that we are entering the Age of Aquarius, the Waterbearer, and they give us warning to protect the earth's supply of this precious resource. As usual in a mystic analysis of crop formations, there is more than one possible meaning.

"We're picking up information we have lost," Isabelle told the tour group, referring to crop circles and sacred sites around the world. "The original sacred temples were spiritual complexes set aside for initiates. As spiritual memory returns, their healing wisdom will be for everyone."

Isabelle predicts that after a period of chaos — but not the cataclysm foreseen by other psychics — spiritual evolution will lead to a serene balance of polarities in the human mind. We will come into our destined time of peace by honoring the evolutionary contributions of masculine dominance while restoring the feminine spirit to a position of equality. Both masculine and feminine energies are needed. Person to person, a change of consciousness about the masculine/feminine totality is already spreading through the noosphere.

Thomas Berry writes movingly of the trust we can have in our future. "In moments of confusion such as the present, we are not left simply to our own rational contrivances. We are supported by the ultimate powers of the universe as they make themselves present to us through the spontaneities within our own beings." (1988, p. 211)

Artists who are practiced in being spontaneous within their own beings and expressing their insights to others may be serving the ultimate powers of the universe by reiterating the mysterious designs in the fields.

30. Lydia Ruyle *Goddess of Healing* (Caduceus) Handmade paper
Litchfield, Hampshire, 1995

31. Lydia Ruyle *Scorpio Bee Mother* (Bee) Handmade paper
Barbury Castle, Wiltshire, 1994

BIBLIOGRAPHY

Alexander, Steve and Karen. *Crop Circles, Signs, Wonders and Mysteries.*
 London: Arcturus Publishers Limited, 2006.
Alexander, Steve and Karen Douglas. *Crop Circle Yearbook.*
 Gosport, Hantsford, UK: Temporary Temples Press, 1999.
Anderhub, Werner and Hans Peter Roth. *Crop Circles, Exploring the Designs and Mysteries.*
 New York: Lark Books/Sterling Publishing, English translation, 2002.
Bartholomew, Alick, Editor. *Crop Circles, Harbingers of World Change.*
 Bath, UK: Gateway Books, 1991.
Berry, Thomas. *The Dream of Earth.* San Francisco: Sierra Club Books, 1988.
Bohm, David. *Wholeness and the Implicate Order.* London: Ark, Routledge, 1980.
Brown, Courtney, Ph.D. *Cosmic Voyage.* New York: Dutton, Penguin Books, 1996.
Caddy, Eileen. *The Spirit of Findhorn.* New York: Harper & Row, 1976.
Campbell, Joseph. *The Inner Reaches of Outer Space.*
 New York: Alfred Van Der Marck Editions, 1985.
Capra, Fritjof. *The Tao of Physics.* New York, Bantam, 1975.
 The Turning Point. New York: Bantam, 1983.
Clow, Barbara Hand. *The Pleiadian Agenda.* Santa Fe: Bear & Co., 1995.
 with Gerry Clow. *Alchemy of Nine Dimensions.* Charlottesville, VA:
 Hampton Roads Publishing Co., 2004
Corso, Col. Philip J. and William J. Birnes. *The Day After Roswell.* New York: Pocket Books, 1997.
Delgado, Pat and Colin Andrews. *Circular Evidence.* Grand Rapids, MI: Phanes Press, 1989.
 Delgado, Pat. *Crop Circles, Conclusive Evidence.* London: Bloomsbury Publishing, 1992.
Denney, Mike. "Walking the Quantum Talk," *IONS Noetic Sciences Review*, June-August, pp.18-23,
 Petaluma, CA: Institute of Noetic Sciences, 2002.
De Quincey, Christian. "Stories Matter, Matter Stories," *IONS Noetic Sciences Review*,
 June-August, pp.9-13, 44-45, 2002.
Devereux, Paul. *Places of Power.* London: Blandford A. Cassell, 1990 edition.
Findhorn Community. *The Findhorn Garden.* New York: Harper & Row, 1968.
Fowler, Raymond E. *The Watchers II.* Newberry, OR: Wild Flower Press, 1995.
French, A. P., Editor. *Einstein, A Centenary Volume.* Cambridge, MA: Harvard University Press, 1979.
Friedland, Norman. *Bridging Science and Spirit.* St. Louis, MO: Living Lake Books, 1990.
Grey, Alex. *The Mission of Art.* Boston & London: Shambhala, 2001.
Haddington, John. "Where Two Worlds Meet," *The Crop Circle Enigma*, editor Ralph Noyes,
 Bath: Gateway Books, 1990, page 176.
Harman, Willis, Ph.D. *Global Mind Change.* San Francisco: Berett-Koebler Publishers, 1998.
 and Howard Rheingold. *Higher Creativity.* Los Angeles: Jeremy P. Tarcher, Inc., 1984.

Haselhoff, Eltjo H., Ph.D. *The Deepening Complexity of Crop Circles, Scientific Research and Urban Legends.* Berkeley, CA: Frog, Ltd., 2001.

Hawkins, Desmond, Editor. *Wessex, A Literary Celebration.* London: Century, 1991.

Hesemann, Michael. *The Cosmic Connection, Worldwide Crop Formations and ET Contacts.* Bath, UK: Gateway Books, 1996.

Howe, Linda Moulton. *Glimpses of Other Realities, Vol. I: Facts and Eyewitnesses,* Huntingdon Valley, PA 1906, 1993.

Howe, Linda Moulton. *Mysterious Lights and Crop Circles.* New Orleans, LA: Paper Chase Press, 2000.

Hubbard, Barbara Marx. *Conscious Evolution, Awakening the Power of Our Social Potential.* Novato, CA: New World Library, 1998.

Jung, Carl G. *Flying Saucers, A Modern Myth of Things Seen in the Skies.* New York: MJF Books, 1978 Edition.

Kaku, Michio. *Visions.* New York: Anchor Books/Random House, 1997.

King, Serge Kahili. *Urban Shaman.* New York: Simon & Schuster/Fireside, 1990.

Klimo, Jon. *Channeling.* Los Angeles: Jeremy P. Tarcher, Inc., 1987.

Kübler-Ross, Elisabeth. *On Death and Dying.* New York: Scribner, 1969.

Kurzweil, Ray. *The Age of Spiritual Machines, When Computers Exceed Human Intelligence.* New York: Viking, 1999.

Lemkow, Anna F. *The Wholeness Principle.* Wheaton, IL: Quest Books, 1990.

LeShan, Lawrence. *Alternate Realities.* New York: Ballantine Books, 1976.

Mandelbrot, Benoit B. *The Fractal Geometry of Nature.* New York: W.H. Freeman & Co., 1983.

Mann, Nicholas and Marcia Sutton, Ph.D. *Giants of Gaia.* Albuquerque, NM: Brotherhood of Life, 1995.

Margulis, Lynn and Dorion Sagan. *Slanted Truths, Essays on Gaia, Symbiosis and Evolution.* New York: Springer-Verlag, 1997.

Miller, Hamish and Paul Broadhurt. *The Sun and the Serpent.* Launceston, Cornwall, UK: Pendragon Press, 1989.

Mishlove, Jeffery, Ph.D. *Thinking Allowed.* Tulsa, OK: Council Oak Books, 1992.

Mitchell, Edgar D., Ph.D. *Psychic Exploration.* New York: G. P. Putnam's Sons, 1974.
The Way of the Explorer. New York: G. P. Putnam's Sons, 1996.

Monroe, Robert A. *Journeys Out of Body.* Garden City, NY: Anchor/Doubleday, 1977.

Moody, Raymond A., Jr. *Life After Life.* New York: Bantam Books, 1976.

Moore, Judith and Barbara Lamb. *Crop Circles Revealed.* Flagstaff, AZ: Light Technology Publishing, 2003.

Nelson, Mary Carroll. *Artists of the Spirit, New Prophets in Art and Mysticism.* Sonoma, CA: Arcus Publishing, 1994.
Beyond Fear. A Toltec Guide to Freedom and Joy, The Teachings of Don Miguel Ruiz. San Francisco: Council Oak Books, 1997.

Newton, Michael. *Journey of Souls.* St. Paul, MN: Llewellyn Publications, 2000.
 Destiny of Souls. St. Paul, MN: Llewellyn Publications, 2002.
Noyes, Ralph, Editor. *The Crop Circle Enigma.* Bath, UK: Gateway Books, 1991.
O'Leary, Brian, Ph.D. *Exploring Inner and Outer Space.* Berkeley, CA: North Atlantic Books, 1989.
Pearsall, Paul, Ph.D. *Miracle in Maui.* Hawaii: Inner Ocean Publishing, Inc., 2001.
Pringle, Lucy. *Crop Circles, The Greatest Mystery of Modern Times.*
 London: Thorsons/HarperCollins Publishers, 1999.
Radin, Dean, Ph.D. *The Conscious Universe, The Scientific Truth of Psychic Phenomenon.*
 New York: HarperCollins Publishers, 1997.
 Entangled Minds, Extrasensory Experiences in a Quantum Reality. Simon & Schuster:
 New York: 2006.
Roberts, Jane and Robert F. Butts. *The Nature of Personal Reality, Vol. I.*
 Englewood Cliffs, NJ: Prentice-Hall, 1977.
 The Nature of Personal Reality, Vol. II. Englewood Cliffs, NJ: Prentice-Hall, 1979.
Ruby, Doug. *The Gift, The Crop Circles Deciphered.* Cape Canaveral, FL: Blue Note Books, 1997.
Russell, Peter. *Waking Up in Time.* Novato, CA: Origin Press, Inc., 1998.
Ruyle, Lydia. *Goddess Icons, Spirit Banners of the Divine Feminine.*
 Boulder, CO: Woven Word Press, 2002.
Sheldrake, Rupert. *The Presence of the Past.* London: Collins, 1988.
 The Rebirth of Nature, The Greening of Science and God. New York: Bantam Books, 1991.
 "The Extended Mind," *Quest,* August, 2003.
Shlain, Leonard, M.D. *Art & Physics.* New York: William Morrow, 1991.
Silva, Freddy. *Secrets in the Fields, the Science and Mysticism of Crop Circles.*
 Charlottesville, VA: Hampton Roads, 2002.
Sitchin, Zecharia. *The Twelfth Planet.* New York: Avon/Hearst, 1976.
Spangler, David. *Revelation, the Birth of a New Age.* San Francisco: Rainbow Bridge, 1976.
 The Laws of Manifestation. Moray, Scotland: Findhorn Community, 1975.
Swan, James A. *Sacred Places.* Santa Fe: Bear & Co., 1990.
Talbot, Michael. *The Holographic Universe.* New York: HarperCollins, 1991.
Targ, Russell and Jane Katra, Ph.D. *Miracles of Mind, Exploring Nonlocal Consciousness
 and Spiritual Healing.* Novato, CA: New World Library, 1988.
Teilhard de Chardin, Pierre. *The Phenomenon of Man.* New York: Harper/Torch Books, 1955.
Thomas, Andy. *Vital Signs.* Berkeley, CA: Frog, Ltd. 1998, 2002.
Thompson, William Irwin. *Passages About Earth.* New York: Harper & Row, 1973.
Thorne, Kip S. *Black Holes and Time Warps, Einstein's Outrageous Legacy.*
 New York: W.W. Norton & Co., 1994.
Tompkins, Peter and Christopher Bird. *The Secret Life of Plants.* New York: Avon Books, 1973.
Toms, Michael. *At the Leading Edge.* Burdett, NY: Larson Publications, 1991.

Vallee, Jacques. *Passport to Magonia, on UFOs, Folklore and Parallel Worlds.*
 Chicago: Contemporary Books, 1993.
Watkins, Alfred. *The Old Straight Track.* London: Sphere/Macdonald & Co., Publishers, 1974-1990.
Weiss, Brian L., M.D. *Many Lives, Many Masters.* New York: Simon & Schuster/Fireside, 1988.
Wilber, Ken. *The Spectrum of Consciousness.* Wheaton, IL: Theosophical Publishing House, 1977.
Wolf, Fred Alan, Ph.D. *Parallel Universes.* New York: Touchstone/Simon & Schuster, 1988.
 The Eagle's Quest. New York: Summit/Simon & Schuster, 1991.

WEBSITES

Mark Fussell and Stuart Dike: www.cropcircleconnector.com
Linda Moulton Howe: www.earthfiles.com
Andy Thomas: www.swirlednews.com
Steve and Karen Alexander: www.temporarytemples.com

ACKNOWLEDGMENTS

For being the conduit between me and the crop circle mystery, I extend heartfelt appreciation to Isabelle Kingston. Her encouragement and her supportive contributions to this book are a source of inspiration to me. Isabelle's connection with crop circles is the intimate one of a neighbor who has seen many of them in fields near her home. Isabelle receives information about the circles psychically, but she has researched them in a studious manner, as well. She believes these patterns hold messages, not of dark foreboding but of potential value for the welfare of the Earth. Through her teaching she has spread knowledge of the phenomenon to many who are drawn to her as a guide. Isabelle's gentle, expansive overview of the crop circle mystery is in harmony with my intention in writing this book.

My appreciation goes to the artists who are disbursing crop circle wisdom through their work, particularly to Lydia Ruyle who has made such a commitment to this task.

I would like to thank Kay Fowler and Nancy Stem for their creative suggestions and for bringing this book into form.

My continued appreciation goes to my husband Ed, without whose patient and steadfast help, the gremlins in my computer would have won and there would be no book.

SPIRITUAL INTERPRETATIONS
Isabelle Kingston

A Self Test
Choose your favorite crop circle image and check for the interpretation.

DNA, Lydia Ruyle (Plate 10, p. 59)
Life Force. Body of humanity, magic within. Qualities in humanity for greatness.

Grandmother Spider Woman's Web,
Lydia Ruyle (Plate 8, p. 27)
Seven Steps into Consciousness. 'Where do you go from here?' Live the dream and plan your future. A support system of spirituality is holding your future for you. Move into the subconscious, travel into your heart and a coming together of wishes, hopes, and dreams will occur. Cast your net upon the waters.

Mandelbrot Black Madonna, Lydia Ruyle
(Plate 17, p. 79)
Order in Chaos. The never ending story—karma, cycle, and mind consciousness. Creative thought and the greater mind.

The Messenger, Ilena Grayson (Plate 27, p. 107)
The Goddess. Balance. Healing. Regeneration. Safety. Feet on the ground, the Goddess stands opening her heart to those who would promote peace. The symbol negating negativity, supporting growth.

Offerings I, Mary Hunter (Plate 26, p. 106)
Coming Together, Power for Good. Information through mind channels. Sharing a Divine Purpose.

Koch Fractal Star, Lydia Ruyle (Plate 6, p. 22)
Creative Power of the Universe. Use the creative power to express yourself. The reality of all things... Travel with the Star, connection with the Gods, The Watchers.

Stonehenge Julia, Lydia Ruyle (Plate 5, p. 19)
The Outer Signs of Humanity Linking With the Cosmos. The unseen power of the Universe, of life and of consciousness. The birth of ideas, creation of a scientific knowledge passed on through dimensions of Truth. Will humanity accept the mission to be greater than they are? Travel into other worlds and access into the knowledge that can be obtained. This is a symbol of the potential fetus and the potential within each individual.

Scorpio Bee Mother, Lydia Ruyle (Plate 31, p. 115)
Face Your Fears. The world of nature is stronger than you think. Survival is the basic instinct. Man cannot dominate nature and you also cannot be dominated. This is a power symbol on the Dragon Line. Earth's ancient wisdom is being challenged. Will you take up the challenge? Can you hold the Truth, your own Truth?

Dragon's Foot, Pictogram, Jack Richardson
predicted by Isabelle Kingston, (Plate 24, p. 102)
Symbol of Magic Totem—Communication, Signals. Open, awake, do the magic. Merlin's Land, the natural flow of things. Face the future. Soft, gentle, evolution, creation. Enormous tranquility, stabilization, peace, Angels.

Caduceus, Lydia Ruyle (Plate 30, p. 114)
Instinct. Gut Feeling. Go forward. Go back. Seek what you need. Find a place of safety within.

Eclipse, Photo by Steve Alexander (Plate 15, p. 74)
Transformation, Eclipse, Openness. Opportunity to seize the day. Into wholeness, release from the past. Concentrate your energy on what you want. A coming together.

Serpent, Photo by Steve Alexander (Plate 9, p. 39)
The Dragon rising up out of the Land, head raised. This is your opportunity to grasp your future. Walk in the way of the ancestors. Remember your sacred connection to the Land. Move forward into knowing the Serpent is awake. The knowing is for ALL waiting to rise as a beacon of wisdom for all humanity.

The Snail, Photo by Edwin Nelson (Plate 2, p. 10)
Survivor. Land of chalk, made of snails. Don't be afraid to stick your neck out. You are safe. Take your time. Be uplifted.

32. Mary Carroll Nelson *Sophia's Mandala* (Nested Crescents) Plexiglas and ink construction
Wilmington, East Sussex, 1995

LIST OF WORKS

Cover: *Out of This World* (Torus), Alton Priors, Wiltshire, 1997
Handmade paper by Lydia Ruyle

1. *Infinity Goddess Triangles* (Logarithmic Spiral), Picked Hill, Alton Barnes, Wiltshire, 2000; p. 2
Handmade paper by Lydia Ruyle

2. *The Snail*, Wiltshire, 1992; p. 10
Photograph by Edwin B. Nelson

3. *Out of This World* (Torus), Alton Priors, Wiltshire, 1997; p. 14
Handmade paper by Lydia Ruyle

4. *Torus*, Alton Priors, Wiltshire, 1997; p. 18
Photograph by Mary Carroll Nelson

5. Stonehenge Julia (Fractal), opposite Stonehenge, Wiltshire, 1996; p. 19
Handmade paper by Lydia Ruyle

6. *Koch Fractal* (Star), Silbury Hill, Wiltshire, 1997; p. 22
Handmade paper by Lydia Ruyle

7. *Galaxy 2001* (Jaw Dropper), Milk Hill, Wiltshire, 2001; p. 23
Handmade paper by Lydia Ruyle

8. *Grandmother Spider Woman's Web*, Avebury, Wiltshire,1994; p. 27
Handmade paper by Lydia Ruyle

9. *The Serpent*, Alton Barnes, East Field, Wiltshire, 1999; p. 39
Photograph by Steve Alexander

10. *DNA*, Alton Priors, Wiltshire, 1996; p. 59
Handmade paper by Lydia Ruyle

11. *The Face*, Chilbolton, Hampshire, 2001; p. 66
Photograph by Steve Alexander

12. *The Code*, Chilbolton, Hampshire, 2001; p. 67
Photograph by Steve Alexander

13. *Crabwood Face and Code*, Near Winchester, Hampshire, 2002; p. 70
Photograph by Steve Alexander

INDEX

Mary Carroll Nelson is an author/artist/teacher. Her interest in crop circles began in 1991. She brings to her subject many years as a writer of art history, biography and metaphysics. In *Crop Circles, An Art of Our Time,* she combines the viewpoint of an art historian with that of artist and seeker to probe the connection between the crop formations and developments in contemporary thought.

Mary Carroll Nelson was introduced to the crop circle mysteries by Isabelle Kingston through her lectures in the United States and England. Nelson has built her thesis on a triadic structure first realized after listening to Kingston's talks.

Isabelle Kingston is an internationally known medium, channeller and healer. Since an early age, she has been aware that she possesses the ability to see and link with many unseen dimensions. After a successful career in banking, she has now devoted herself to spiritual work. She teaches and shares her knowledge of ancient sites, crop formations, dowsing and personal growth.

Lydia Ruyle creates Goddess Icon and Crop Circle banners, exhibits them and teaches workshops throughout the United States and internationally. She has taught a course in Herstory for many years at the University of Colorado at Greeley. In her book, *Goddess Icons, Spirit Banners of the Divine Feminine,* she combines her art with scholarship related to the image of the Goddess in world cultures.

52884